HIDDEN

HISTORY

of

ROANOKE

HIDDEN HISTORY

HISTORY

of

ROANOKE

Star City Stories

NELSON HARRIS

Charleston London

THE
History
PRESS

Published by The History Press
Charleston, SC 29403
www.historypress.net

Copyright © 2013 by Nelson Harris
All rights reserved

Front cover courtesy of the City of Roanoke.

Back cover photo courtesy of Greg Vaughan and the City of Roanoke.

First published 2013

Manufactured in the United States

ISBN 978.1.60949.993.8

Library of Congress CIP data applied for.

To Katie and Jack

CONTENTS

PREFACE

"The metropolis provides what could otherwise only be gained by traveling; namely, the strange," so penned Jane Jacobs. Welcome to Roanoke's hidden history or "the strange" of our Star City!

This collection of the sensational, curious, odd, tragic and heroic seeks to offer what is overlooked or forgotten in our more formal local histories; yet they are events that captured the imaginations and attention of Roanokers at the time of their occurrence. In some ways, they are a reflection of my own musings about what life was like in my hometown. I have often wondered, for example, what happened in Roanoke the night before Prohibition. Or the tales of mischief and, in one case, murder about which I have heard older Roanokers speak, as if sharing something that happened only last week. There were the wild days of Roanoke's early years, when police were few and scandals numerous. There were events national in scope that had an impact on Roanoke, such as the flu pandemic of 1918 or Negro League baseball. The details of these Star City stories have been harvested from interviews and archival newspapers in an effort to use primary sources whenever possible.

This eclectic compilation of narratives is not produced solely to entertain or enlighten but to remind us that Roanoke's story is a very human one, and as such, we find the multifaceted elements of our nature. The murder of a Jefferson High School student gripped our city in the summer of 1949 and stole the innocence of the sock-hop days. One of our city's best-known businesses was birthed from dealings that at best were shady and at worst,

outright illegal. On hot summer nights, men swung a bat and chased fly balls in an era when the color of their skin prevented them from hoping to play professionally. Young women from all across the country refined themselves under the care of matrons at a college in South Roanoke whose buildings contained deep, long porches and parlors, while at the same time, and across town, the children of Norwich toiled at spinning cotton. The stories are as varied as the people contained in them.

I am indebted to the resources, collection and wonderful staff of the Roanoke Main Library's Virginia Room and the reservoir of information contained there without which this book would not have been possible. I also wish to express my appreciation to Melinda Mayo, with the City of Roanoke, for her assistance.

Chapter 1

THE VAGABONDS

They started in Pittsburgh in the summer of 1918 and moved south with no real itinerary except to eventually reach Asheville, North Carolina. The four vagabonds planned to take two-lane roads, avoid hotels and camp roadside.

They wanted to see the mountains and relax. They pitched tents, cooked outdoors and reminisced. They stopped at abandoned gristmills and along rivers and rested in pastures. They cared little for encounters with others, though they were friendly if their presence was noticed. They were older and found pleasure in the simple companionship of close friends. "Vagabond" was not meant as a derogatory term by any means, for that's what they called themselves.

As they traveled through the Blue Ridge Mountains, they passed Bluefield, Elkins, Hot Springs, White Sulphur Springs, Narrows and, eventually, Asheville. An occasional photograph was taken, usually by residents of these communities who were curious about the vagabonds' presence. As they began their return to Pittsburgh, the men journeyed to Winston-Salem and then north through Martinsville and Franklin County.

About noon on August 30, the vagabonds slipped quietly into Roanoke. Mrs. Fred Foster was managing the Hotel Roanoke, having taken over the role from her husband, who had died three years earlier, and Ed Brown was the headwaiter when the vagabonds stopped to have lunch. They did not look like vagabonds, as each was attired in suit and tie. They were unannounced, their lunch at the hotel necessitated by the lack of gasoline

for their cars. They had stopped at the corner of Jefferson Street and Shenandoah Avenue in front of the Red Cross canteen station and sent for fuel. The hotel, being close, was convenient. Foster and Brown, like others at the hotel that afternoon, were struck as they watched the four vagabonds—Henry Ford, Thomas Edison, tire magnate Harvey Firestone and naturalist John Burroughs—walk through the lobby doors.

They were served lunch and shown hospitality. Henry Ford was fashionably thin in his three-piece suit, graying hair parted neatly to the side. Edison sported a bit of a paunch and a bow tie, with hair looking anything but combed. Burroughs was the eldest, at eighty, and his bushy white beard hung below the knot of his necktie, while Firestone wore travel clothes.

As the men dined, Roanokers could not help but notice the vagabonds' parked caravan of two brand-new Fords and a large Packard. There were also two specially equipped Model T trucks that carried each man's ten-foot-square tent, a twenty-foot-square dining tent, a nine-foot dining table with "lazy Susan," water tanks, stoves, an Edison-arranged refrigeration system for provisions and a small, portable electric contraption that lighted Edison's lamps strung each evening at their campsite. The caravan also included a chauffeur and cooks. By the time the men had consumed lunch and walked down the front steps of the Hotel Roanoke, a small crowd had formed as word was circulating of the vagabonds' arrival.

As they awaited the supply of gasoline, the crowd became more numerous and was soon being engaged by the gregarious Ford, described as "all energy," who shared stories, laughs and explained the group's travel. One citizen, Robert Wilson, asked Ford about bringing an automobile plant to Roanoke. Ford, whose business interests had broadened beyond automobiles, replied, "Oh! You have a fine enough country down here for anything, but just now I am talking tractors and water power." The industrialist commented that the resource of water and its commercial potential is what had caught his attention driving through southwestern Virginia. Ford offered impressions on road conditions, especially between Martinsville and Roanoke, and punctuated all of his remarks with good humor. Ford even joked about his U.S. Senate candidacy, which was ongoing in Michigan. He had been rejected by the Republicans and so was running as a Democrat (an election he would narrowly lose).

As Ford regaled the crowd, Edison quietly studied the afternoon editions of the Roanoke newspapers keenly interested in news of the war. Burroughs and Firestone assisted with the refueling.

By four o' clock that afternoon, the caravan was ready to travel. Before climbing into the lead Packard, Ford addressed the crowd: "You have a wonderful country hereabouts and a wonderful people living in it."

The vagabonds headed north through the Shenandoah Valley, stopping briefly at Natural Bridge and overnight at the Castle Inn between Lexington and Staunton. They made their way to Winchester and then into Maryland. In Maryland, a state forest warden, Link Sines, was invited to guide the entourage through one of the state parks. As he did, the caravan stopped at a small hardware store to purchase supplies. Sines thought it appropriate to introduce the group to the store's proprietor, Mr. Naylor. "Mr. Naylor, I'd like to introduce you to Thomas Edison; he invented that light bulb in your ceiling. This is Henry Ford; he manufactured that car parked outside your store. And this is Mr. Firestone; he made the tires that are on your car."

The skeptical Naylor looked at Sines and interrupted, "And I suppose you're going to tell me that this man [Burroughs] with the white beard is Santa Claus!"

Fortunately, the vagabonds required no introductions in Roanoke.

———•·•·•———

The vagabonds continued their camping trips for many years, though Burroughs died in 1921. In the early 1920s, they took with them on separate occasions Presidents Harding and Coolidge. For a decade between 1914 and 1924, the vagabonds camped and traveled along the East Coast, demonstrating both the versatility of the automobile and the pleasure of camping. These excursions, which eventually became well publicized, are credited with launching family-oriented, recreational camping in America.

Chapter 2

A MOMENT IN *TIME*

The July 13, 1962 edition of *TIME* magazine caught the residents of Willowlawn Avenue in Roanoke County by surprise as an article about "new breed" young Republicans in the South contained a photograph of a man who looked very familiar.

Bill Cobb was a man of political ambition and, at thirty-nine, was on the rise in North Carolina Republican circles. Five years earlier, he had served a term in the state senate and was now the state chairman of the North Carolina GOP. In the summer of 1962, Cobb was running for his old state senate seat, and his good looks, personal charisma and unwavering sense that Republicans could win in southern states had catapulted Cobb into the limelight. He had caught the attention of the editors at *TIME*, and some Washington insiders were strongly encouraging him to consider a run for Congress. His office wall was adorned with photographs of Nixon and Eisenhower, and he did not mind giving his opinion about Democrats, even if his home and business were located in Morganton, the same town of the then United States senator Sam Ervin, a powerful and nationally influential Democrat. Some attributed his feisty manner to his New York roots or his Yale Law School education or his U.S. Marine Corps flight training. Regardless, Cobb was a man who had made himself comfortable in North Carolina through his marriage to Mildred Huffman, daughter of a prominent Morganton lumber dealer. Cobb, who came from a family of means, bought his father-in-law's business and took full advantage of the business and social connections that came with it. He and Mildred adopted

a son, and this completed a well-rounded profile for Cobb that ingratiated him to many in the Tar Heel State.

When it was learned that *TIME* magazine had chosen to include him among the four young Republican southerners it planned to profile, his circle of friends and associates thought it quite natural for a man who had accomplished so much so quickly. *TIME* wanted to give special attention to inroads that were being made by some Republicans in the solidly Democratic South. The fact that Cobb had managed to break through in Senator Ervin's backyard put him on the radar screen.

It was a late summer night on a dead-end residential street in Morganton when two reporters and a photographer from the *Charlotte Observer* found Cobb coming out of a meeting with precinct workers for his senate campaign. Cobb, sharply dressed in a suit, moved toward them and extended his hand on his way to the family station wagon with a bumper sticker that read, "Cobb for Senate." But the reporters were not there that night to discuss his campaign; rather, they had become keenly interested in what some on another quiet residential street—Willowlawn Avenue in Roanoke—were saying about Bill Cobb, a man many swore they knew as Ed Cobb.

The *TIME* article carried a photograph of a smiling Bill Cobb, the noted lumber dealer, Republican and married family man. For the residents of the 2400 block of Willowlawn, however, this was Ed Cobb, a man they knew to have some conservative opinions but who was mostly apolitical, claimed to be an "airplane investigator" and was often away on business and whose modest, contemporary-style home where he had lived for the past two years was graced by his beautiful wife, Linda, and their two preschool sons. There had been a few cocktail parties at the Cobb home, and neighbors had offered food and good wishes when the Cobb sons were born. While a few Willowlawn neighbors dismissed the gossip about the men being the same person, a few found some other striking similarities between the man they knew and the one in *TIME* magazine. Both men traveled significantly and were trained pilots, and even though "Ed Cobb" of Roanoke lived in a small, leased home, he always drove a late-model Edsel and had a private Piper Comanche at Woodrum Field. One neighbor decided to make a phone call to the *Roanoke Times* that launched an investigation by *Times* political reporter Melville Carico and others, and while Carico may have been skeptical at first, he soon concluded that the residents of Willowlawn had accurately suspected that Ed Cobb and Bill Cobb were the same man.

The license tag on Cobb's car, parked at his Roanoke house, was registered to a lumber company in Morganton, and the plane at Woodrum

Field was also registered to the same. Records showed the plane had flown between Roanoke and Hickory, North Carolina, twice a month for at least eighteen months. Carico's calls to the Cobb home had proved unfruitful, as Linda Cobb twice asserted that it was a case of mistaken identity. Carico knew better.

As the Charlotte reporters watched Cobb walk out the front door from his precinct meeting, they were prepared with what Carico had uncovered. As they greeted Cobb, he continued moving to his car, opened the driver's door and sat inside with the window down.

"Mr. Cobb, some questions have come up as a result of your appearance in *TIME* magazine. Some questions we've already answered, but you will have to supply the answers to others." Kays Gary and Jack Claiborne of the *Observer* were on deadline.

Cobb's face went noticeably pale, and his voice lost its usual cadence. "What questions?" he asked. For fifteen minutes in the darkened street, Gary and Claiborne laid out their evidence of Cobb's double life. He then invited the reporters back to his business office, where the three continued talking for another ten minutes as Cobb spoke in a calm, unemotional manner.

"Well, gentlemen, it's true. I'm guilty. This is going to hurt a great many people. Of course, I don't matter. But there are a number of children involved, and I love them all." Cobb pressed forward with his confession. "There's my wife, and there's my consort in Virginia who is the mother of my natural children. There's my own mother. All innocent people, but there it is."

Cobb stated he would immediately resign his post as chairman of the North Carolina Republican Party and his candidacy for the state senate, and then he rose from his chair, ending the interview, and breathed deep. "Now I've got to call my legal wife before somebody else does...I hope nobody else has."

Within twenty-four hours of confessing, the real story of William Edward Cobb was being told. Though married, he had met and begun a relationship with Linda Renfrew Parker, a divorcée and former beauty queen, in 1959. Fathering two children, Cobb had chosen to make a home in Roanoke with Linda, who was aware of his wife and son in Morganton. They operated as a married couple, inviting neighbors into their Willowlawn home, setting up charge accounts at stores in Roanoke under the name of "W. Edward and Linda Cobb" and functioning in all ways as husband and wife. Cobb was not an "airplane investigator," but it provided a reasonable explanation for his plane and travels.

Contacted by reporters, Linda eventually admitted that she had known the day would come when her and Cobb's situation would be revealed. "We knew from the beginning this would be a possibility. We just didn't know how the fireworks would start." Once Cobb's photograph appeared in *TIME*, she said she had planned to leave Roanoke quickly to avoid suspicion, but time was not on her side. As her neighbors read about or heard Cobb's confession through local media, some went to her home and expressed concern and care for her and the boys. "For personal interest, I'd like to say how considerate and nice the Roanoke people have been. To me that has been quite interesting," she told *Times* managing editor Norwood Middleton.

As "Linda Cobb" dealt with reporters in Roanoke, Bill Cobb's lumber office in Morganton buzzed with activity as journalists and television cameras descended on him. Sitting behind his desk, Cobb chain-smoked his way through the day, answering calls and "getting this over with," as he put it. His receptionist, acting on Cobb's direction, escorted reporters to a waiting room, served them Cokes and arranged times for each to have access to her boss. Cobb was willing to talk about everything, except Linda. Cobb's demeanor was businesslike as he told reporters that he planned to remain in Morganton, tend to his business and recommit himself to his family, even announcing plans for him, his wife and their son to take an extended month-long vacation.

The scandal subsided almost as quickly as it had erupted. With Cobb's quick confession and willingness to answer questions, reporters wrote a few more stories and then melted away. Bill Cobb's double life had stunned his friends and colleagues, rocked North Carolina state politics and unveiled the hidden life of a man whose career and ambitions seemed unlimited. Kays Gary of the *Observer* noted, "One after another, Morgantonians expressed disbelief and inability to understand why an educated man, a brilliant man, a Yale man, a man who had everything going for him, could do such a stupid thing."

By the end of the first week in August, Linda Renfrew had packed her suitcase, a playpen and her two infant sons in the back of her black Edsel and pulled out of her Willowlawn driveway. With Roanoke in her rear view mirror, Linda motored away to a new life. Whether any friends came to see her off is not known, only that a few days later neighbors saw a For Lease sign on the Cobbs' front lawn.

On August 3, *TIME* magazine ran a follow-up story, entitled "I Led Two Lives," on the impact of its profile of Cobb as the magazine had exposed him by running his photograph. "Success was his undoing. When his picture

ran in *TIME*, July 13, as North Carolina's G.O.P. Chairman...it was spotted by a neighbor in Roanoke. Cobb was not particularly worried when he found that *TIME* was including him in its story, but he did not know his picture would be used. 'I didn't even know they had a picture,' he said later, 'although I should have realized that one was available to them. The picture is what really hurt."

William Edward Cobb continued in his Morganton lumber business for the next several years after his personal scandal. He wrote a political novel, *An Inch of Snow*, that was published in 1964. The following year, he and his wife, Mildred, divorced. He left North Carolina in 1972 and moved to New Mexico, where he remarried, entered the real estate business and remained involved in state Republican politics. He died there in 1990 at the age of sixty-seven. Mildred Huffman remarried and remained in the Morganton area until her death in 2004. As for Linda Renfrew, she and her two sons eventually made their way to Florida, where the sons live today. In an interview in the late 1970s, Cobb indicated that he and the two sons "remained close."

Chapter 3

THE DEATH WAVE

A boy at the Baptist Orphanage in Salem left in early September 1918 for a week's work in Hopewell, Virginia. Shortly after his return, the teenager complained of chills and a fever, so he was admitted to the orphanage's infirmary, and Dr. Macon Smiley was called. Upon the doctor's arrival, the patient was complaining of body aches and watery eyes, leading Dr. Smiley to readily diagnose the flu. The physician prescribed bed rest and fluids and asked the infirmary nurse to keep the young man quarantined.

Within a few days, eleven more boys from the orphanage were in the infirmary exhibiting the same symptoms. By week's end, the number had grown to twenty-three, and all were under the watchful eye of Mrs. Mary Dunton, the orphanage's nurse for the past twelve years. Dr. Smiley visited daily and was confident his young patients were managing their illnesses satisfactorily and sensed no need to alarm the community. By keeping the boys confined to the infirmary, the influenza going around the orphanage would be contained.

While Dr. Smiley and Nurse Dunton were tending the orphans, a student at Hollins College had been admitted to the infirmary there the same week complaining of flu-like ailments. By week's end, eighty Hollins students had been quarantined in the college infirmary. Physicians attending the Hollins students felt confident that the outbreak of influenza on the campus could be contained with proper medical attention.

Both of these outbreaks occurred as Roanokers were attending in record numbers the sixteenth-annual Greater Roanoke Fair. Though reports of the

flu at the Salem orphanage and Hollins College were noted in the local newspapers, the items were brief. Roanokers were aware of the "Spanish flu" afflicting a few military bases and troops overseas, but local doctors were confident that no such outbreak would adversely affect the Roanoke Valley and said as much publicly, citing the successful containment of the illness at the orphanage and Hollins.

Then, on September 26, thirty laborers of the Norfolk & Western Railway who had taken a train in from Pearisburg a few days earlier became suddenly sick and were admitted to the city hospital. The number of boys in the Baptist orphanage infirmary had now grown to fifty-eight. Of particular interest was the rapid death of W.W. Eastwood of Highland Avenue, Southwest, who had gone home from work early one day with chills and a fever, received concerned visitors at his home the following morning and was dead by noon. The city health director, Dr. Brownley Foster, had asked the Eastwood family to conduct a private burial limited to just immediate family. Eastwood had died of pneumonia as a result of influenza.

Foster assured the city that the influenza outbreaks in the region were contained, and "there is no occasion for panic in Roanoke." He asked for all to take a "sane, calm view" of the matter when he addressed an assembly of students at Roanoke High School. Foster encouraged doctors, nurses and ministers to wear gauze masks when making in-home visits to patients and affirmed what the United States Surgeon General had stated was the best remedy for influenza—bed rest, fresh air, abundant food and Dover's powder for pain relief.

Concern within the city seemed to register with few as crowds continued to swell the exhibits and shows at the Greater Roanoke Fair and social life continued as normal with various clubs and fraternal organizations meeting regularly. Foster's view and call for calm was affirmed by others in Roanoke's established medical community. Dr. George Lawson made a visit to Hollins College and shared that the situation there was "very satisfactory"—that was, until the first student who had been admitted to the infirmary, a Miss Mapps, died.

By October 1, the ranks of the infected had swollen to 105 at the Baptist orphanage, though 40 had recovered and been discharged back to their dorms.

Mr. Bell Litchford of Eleventh Street, Northwest, became the third to die from influenza. Two days later, Mrs. J.B. Junkin became the fourth.

In the first few days of October, several hundred Roanokers were reporting flu-like symptoms, and at the Baptist Orphanage, Nurse Dunton succumbed to the flu. She was the fifth victim, and her loss was felt throughout the Salem

community. When the children had first been admitted and quarantined at the infirmary, Mrs. Dunton refused to leave them, eating all her meals and sleeping at the infirmary. She had faithfully attended to the orphans even while ill herself.

With five deaths and hundreds in the hospital or confined to their homes suffering from influenza, Foster convened the city's health commission to develop a response to the growing pandemic. The board decided to wage a campaign of public education by publishing and distributing leaflets on the "Spanish flu," noting its symptoms, treatment and possible prevention; calling on the clergy to speak about the same in their churches on Sunday; and encouraging persons to limit out-of-town travel to that deemed necessary. Further, the physicians asked all theater managers to turn away any patrons who looked sick or were coughing and directed that any flu victim's funeral be private. Finally, local physicians were to immediately report all cases of influenza to the board. The one action the board of health did not recommend was the closing of public facilities and gatherings.

Mrs. S.W. Jamison, head of the local Red Cross chapter, offered the chapter's assistance by providing trained student nurses to make home visits as physicians might direct. Roanoke school superintendent D.E. McQuilkin convened teachers at Roanoke High School and asked for volunteers to aid the nurses and doctors with whatever assistance might be required due to the burgeoning patient load. Twenty-five volunteered. While McQuilkin was addressing the white teachers, Foster was meeting with the city's black teachers at Harrison School for the same purpose, and he gained twenty volunteers.

Foster began to sense what was confronting him. The influenza strain was coursing through the city and surrounding counties, and the physicians were overwhelmed. Some thirty-six doctors in Roanoke had received commissions in the United States Army or Navy and were stationed elsewhere. This represented 40 percent of the physicians who, only a year earlier, had been practicing in the city. Foster asked citizens and nurses to call doctors as early in the morning as they could so the physicians might have time to make their house calls before nightfall.

On October 8, with an average of eighty to ninety new cases of the flu being reported daily, Foster went before the city council and asked that the city effectively close. Council readily concurred and declared that "at once" all churches, schools, theaters, pool halls, bowling alleys and dance floors close until further notice. Foster also added to the list fraternal organizations. He also directed that streetcars operate with their windows open in order to

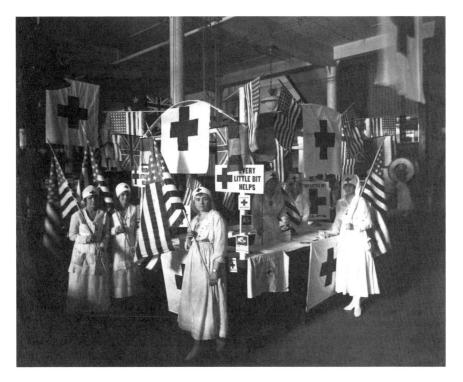

Roanoke Red Cross nurse volunteers in 1918, many of whom served tirelessly during the flu pandemic that year. *Virginia Room, Roanoke Public Library.*

create a swift circulation of air through the car as it moved and that police strictly enforce the city's "anti-spitting laws."

The community fully cooperated. The Masons and Shriners abruptly cancelled their meetings slated for that same night, and the Ministers' Conference in a meeting at the YMCA pledged its support. Calvary Baptist Church and Greene Memorial Methodist Church halted their respective weeklong revival services, and the state convention of the Woman's Christian Temperance Union at First Baptist Church dismissed.

Theater managers complained little as they closed their doors, citing dwindling crowds at their shows that had eroded any profit margin. When Foster was asked what they should do about their employees, the city health director told the theater owners that their employees should find work elsewhere. Foster knew that "until further notice" meant at least several weeks.

The city police force brought before a judge the next morning several who had violated the anti-spitting laws, and they were severely punished.

Among those before the court on October 9 was a billiard hall operator who had kept his establishment open. He was threatened with jail and promptly agreed to comply.

By October 10, Foster was reporting 919 cases of influenza in Roanoke City. He ordered all soda fountains and restaurants to stop serving drinks in glasses and use disposable paper cups. At the Chesapeake & Potomac Telephone Exchange, Manager N.O. Wood was having his own problems. Fourteen of his telephone operators were out sick, and eleven others had been sent to other communities in desperate need of operators. Pulaski, for example, had no operators available to serve its community, as all were ill. Thus, Wood had no choice but to encourage his customers to make only emergency calls and declared that long-distance calls would be "indefinitely delayed." Physicians and nurses had complained they could not make or receive calls due to the few operators available to operate the telephone switchboard.

Foster soon realized he was directing a public education campaign as much as a medical effort. His office began issuing daily reports on influenza cases and deaths, and to complicate matters further, some residents were refusing basic medicines such as aspirins. Apparently, a nationwide rumor had taken hold that aspirin had been contaminated with the flu germ by the Germans. Foster did his best to dispel the notion. The Red Cross was continuing to ask for nurse volunteers and broadened its request to include all women who might be able to assist with the care of young children whose mothers were ill and fathers working.

Amid the growing flu pandemic, Roanoke's political and business leaders were leading the local effort to sell war bonds. Large ads graced the daily newspapers, and despite yeomen efforts, the bonds were not selling. The city manager and others discerned that citizens were afraid to go to banks, so Foster was asked to assist in the bond campaign. "The epidemic of Spanish influenza should keep no one from buying Liberty Bonds," declared Dr. Foster, adding, "Going to the bank is as safe as going to the grocery store." With such assurance, the sale of war bonds immediately picked up.

By October 12, 1,124 persons in Roanoke were infected with influenza, and 20 deaths had occurred in the previous two weeks. The Red Cross chapter made an appeal for male volunteers to assist its nurses, as many did not have the strength to move their larger patients.

With churches closed, the *Roanoke Times* decided to publish one sermon per week. "As long as the influenza necessitates the closing of the churches, the *Roanoke Times* will carry a sermon...such as will meet the mutual interest

and attention of Protestants and Catholics, Gentile and Jew, white and colored." The Reverend P.B. Hill of Second Presbyterian was the first to pen a message, and the remaining schedule of clergy was organized at the newspaper's request by the Ministers' Conference. While churches and synagogues remained closed for congregational gatherings, their offices stayed open to receive visits and offerings and to allow persons to come and worship individually or as families.

Some began to see the flu pandemic as an opportunity to prey on a gullible and desperate public. In an era of unregulated pharmaceuticals, advertisements appeared offering all kinds of preventative and curative antidotes for the flu. "Every Good Physician Ought to Prescribe Nuxated Iron," said one. Dr. Hartman's World Famous Peruna, Calomel Tablets, Hyomel's Inhaling Outfits and Pro-Phy-Tol mouthwash all boasted to relieve the flu and had to be mail ordered. The most interesting advertisement was local. The W.E. Wolfendon Electric Company on Campbell Avenue boldly declared that its vacuum cleaners "moved the flu" as it purified a home's air. "It removes all germs," including the flu, it claimed.

The Heironimus Store sought to assuage its customers that it was safe to shop. The store was "Safe, Sanitary, and Satisfactory for Shopping." A full-page advertisement alerted customers to its practice of fully disinfecting the floors nightly with a sweeping compound.

Foster appeared before the city council on October 13 and sought relief for the poor. The night before, an indigent man, having been diagnosed with the flu, died alone and without medical aid, and the city health director felt there were many more susceptible to the same. The council granted Foster's request that any persons who could not afford proper medical care and lived alone would be admitted to a hospital and their medical expenses paid by the city.

By October 15, Foster reported 2,131 cases of influenza as new cases continued to mount daily. One-third of the city's police force was ill. Experienced nurses were offering training in their homes to help alleviate the need to teach volunteers. Druggists were low on supplies. By mid-October, the *Roanoke Times* voiced what Foster and his colleagues were quietly stating: "The crest of the death wave has not yet reached this city." It was a somber forecast and true.

Roanokers began following the lead of the city's postal clerks, who took to wearing gauze facemasks to work. Pedestrians downtown avoided conversation, walked rather than rode the streetcars and covered their mouths and noses with white handkerchiefs.

The commonwealth's attorney Clifton Woodrum sought and gained permission from the commissioner of Prohibition to dispense confiscated whiskey in urgent cases where prescribed by a physician. Woodrum allowed physicians or those with a prescription to pick up their whiskey from his office in the municipal building between 10:00 a.m. and 4:00 p.m. and made it known that no whiskey would be available at night.

On October 19, Foster declared that the number of influenza cases exceeded three thousand, meaning some 15 percent of the city's population was infected. The total dead of influenza-related illness reached fifty a few days later. Roanokers read the society columns of other communities in their daily newspapers, and the news was never comforting. Lynchburg and Pulaski were severely stricken with the flu, and death totals around the state made headlines.

The Red Cross chapter was strained and unable to keep pace with the increasing need for home visits. It begged for volunteers. The chapter began a clothing drive for young children whose need for clean, warm gowns; stockings; and coats had increased with the onset of fall temperatures. Ill mothers no longer able to cook had warm meals brought to them by Red Cross workers and Boy Scouts, who got the food as it was prepared in the kitchen at the YMCA. Three residents donated their automobiles for the effort.

Foster met with the black Ministers' Conference and received its affirmation and appreciation. The black community was less affected than the white community, possibly due to the presence of all the black physicians as the United States military granted medical commissions only to white doctors. Further, black nurses and teachers had volunteered in significant numbers to aid those who were ill and assist the doctors.

Due to the number of white physicians serving in the military, the Jefferson Hospital had closed temporarily, and Foster assured the community that he would reopen that hospital if beds were needed, but as other hospitals had beds available and most patients were being treated at home, the space at Jefferson was not required.

By October 24, total cases of influenza in the city numbered 3,426. The Red Cross began sending black volunteer nurses into white homes to provide care, a practice unheard of prior to the pandemic. The nurses were well received, and the *Roanoke Times* reported they were "rendering invaluable service." The Red Cross appealed for blankets and quilts to be distributed to homes where needed since patients slept in bedrooms with windows open.

The number of displaced employees was significant due to the closings of schools and theaters. Superintendent McQuilkin assured all teachers

that they would continue to be paid while schools remained shuttered, and theater owners were giving their employees half salaries. Many teachers had stepped in as volunteers with the Red Cross or had formed knitting circles to provide items for the military. Others were helping harvest apples at orchards in surrounding counties.

By late October, with the pandemic stabilized, the influenza gripped Norwich. Thirteen women at Norwich's Twine Mill had volunteered to serve as nurses in the small neighborhood, and eleven became infected themselves. One-fourth of the workforce at the Twine Mill had the flu. Mrs. Lydia LaBaume of the Red Cross's Visiting Nurses Office had no more nurses available, so Norwich was left to fend for itself.

Foster directed that all merchants adopt a "no returns" policy on goods sent out from their stores as items could come back to them infected. He especially urged caution in the sale of tobacco products, directing cigar shops to prohibit customers from handling cigars and pipes unless customers planned to purchase the items they touched.

As Foster managed the pandemic with the resources and knowledge he had, he was able to provide the community with good news toward the end of the month in that there was a decline in new cases of the flu. Druggists were also stating that they were seeing mild forms of the flu being successfully treated by patients purchasing various remedies. With the public well educated, cases leveling off and the death rate declining, Foster asked that city council lift the ban on public gatherings but in a measured way. National Business College was allowed to open on October 28 under the supervision of the city health commission with the understanding that students from infected homes would not be allowed to enroll. The Jewish synagogue and churches could open for one service only on November 2 and 3, respectively, and theaters could show one production at night beginning Monday, November 4. Foster met with the ministers and prohibited the receiving of the Eucharist from a common cup, allowing it to be received only by intinction. Foster released schools to open on Monday, November 11, barring an increase in flu cases.

The last two days in October seemed to confirm Foster's assessment as there were no flu-related deaths reported, and the Red Cross had received no calls for home visits. As the city health director, Foster provided a line graph to various community groups outlining the progression of the pandemic in the city, and the flu appeared to spike on October 11. The month had taken its toll. During the thirty-one-day period, there had been 4,001 reported cases of influenza with an estimated 2,000 cases not reported. The number of influenza-related deaths for the month was 85—77 whites and 8 blacks.

With the ban on gatherings lifted, Foster warned the city not to become too relaxed as there were still thousands infected.

Roanokers flocked to houses of worship and theaters. Attendance at worship services was reported as high, and the theaters had sold-out shows. The Isis and American Theaters reopened with two films starring Norma Talmadge, and the Roanoke Theater launched a vaudeville act headlined as *Five War Widows*. By week's end, the Roanoke was packing its house for a musical revue, *The Naughty Princess*, which starred twenty-five girls billed as a "bevy of Broadway beauties." At the Roanoke Fairgrounds that week, Washington & Lee played Virginia Polytechnic Institute in football.

Foster urged the local physicians to immediately report any new cases, as he was quite anxious about residents resuming normal social activities. Mrs. LaBaume closed the Visiting Nurses Office in the Municipal Building and left town to visit an ill relative. The flu still dominated local news as Foster expressed guarded confidence.

On November 11, a banner headline on the front page of the *Roanoke Times*, "Peace on Earth," turned the attention of Roanoke and Americans elsewhere—to the signing of the Armistice ending World War I. Just days after Foster declared that there be caution about public gatherings, thousands from the city gathered for a public service of prayer and thanksgiving in Elmwood Park. Ministers spoke, bands played and the city's Greek citizens waved their national flag. Hobbie Brothers had supplied three thousand songbooks containing hymns and patriotic music as the crowd sang boisterously, concluding with "All Hail the Power of Jesus' Name." So much for caution.

Fortunately for Roanoke, the influenza pandemic subsided—slowly. Thousands still were bedridden, but new cases dissolved to a trickle in comparison to October. Whereas October had seen an average of three deaths per day due to influenza-related illness, usually pneumonia, November averaged one per day. Soon, reports about the flu were relegated to just a paragraph within the local dailies and then fell off to less than an article per week. The influenza pandemic would remain in Roanoke into 1920, with that year having the last recorded death.

The flu pandemic of 1918 was not the first major public health scare for Roanoke. The city's public health board had formed in 1882 to address smallpox. In 1895, fifty Roanokers died from cerebrospinal meningitis,

many dying within twelve hours of being stricken. There was an average of thirty cases of typhoid per month in 1902, and fifty-four infants in Roanoke succumbed to diarrhea in 1911.

Without question, the flu epidemic of 1918 was the most difficult. Globally, the flu pandemic killed an estimated 50 million people, three times more than were killed in World War I. In Virginia, 15,678 persons died from influenza-related illnesses in the twelve months between September 1918 and September 1919.

October 1918 would not be the last time influenza plagued Roanoke before the pandemic ended. Persons continued to get the flu throughout 1918 and 1919, but the case numbers were low. Then the flu returned in force in February 1920, when over two thousand were infected and nearly one hundred died. As before, schools and churches were closed for a few weeks until the influenza abated.

Dr. Brownley Foster was the city of Roanoke's first public health director, having been appointed to the position in 1910. Prior to his office, public health was in the hands of a sanitary inspector who was a member of the police force. Dr. Foster served as Roanoke's health director until 1924, when he moved to Richmond, Virginia, to assume a similar post. He died there in 1943.

Chapter 4

ROANOKE COMMERCIAL CLUB

L̲arge mirrors, plush chairs, Belgian carpets, billiard tables, writing desks supplied with stationery and ink wells, the tidy display of the major metropolitan daily newspapers, fresh floral bouquets, a reception room, telephone and a small meeting room just off the grand lounge—these were a few of the amenities afforded members of the Roanoke Commercial Club located on the second floor of the Exchange Building in downtown Roanoke.

It was 1890, and Roanoke was open for business. "If a person meets a friend on the street and wants to have a confidential chat, this is just the place for it," noted the *Roanoke Times*. "It is a mighty lever. The union of forces which the Commercial Club represents can do three-fold the work of its individual members acting separately."

The Roanoke Commercial Club formally opened on September 27, and its initial membership roster read like a who's who of Roanoke's business class. R.H. Woodrum was president, and the board of directors included luminaries of Roanoke's early history—Joseph Sands, Peyton Terry, James Simmons, E.H. Stuart, Henry Trout, J.M. Gambill, Dr. Joseph Gale and the Fishburns. These men were bankers, judges, physicians, railway officials and entrepreneurs. But the driving force behind the Commercial Club was a Kentuckian, Hinton Helper.

Helper had organized a similar club in Louisville, and he saw the potential for one in the Magic City. The purpose of the club was to provide a well-appointed gathering place for businessmen to meet, socialize, debate the issues of the day, entertain out-of-town guests and lobby those guests to

invest in Roanoke. Helper envisioned a club that would eventually reach one thousand members and would be the driving force behind shaping and growing Roanoke's varied industrial and business enterprises. So enamored were the members of the club with Helper that there was talk of commissioning his bust to adorn the main entrance. Helper was the club's secretary, and with that came a clubhouse office and a large salary.

Helper had caught the attention of Roanoke's business leaders when he penned a lengthy article on the city and its commercial potential for the *New York Sun*. Helper's column gushed with compliments about the city and the certain return on any investments made there. Helper was subsequently invited to speak in Roanoke and, while addressing an adoring audience, touted the idea for a Commercial Club. Such clubs were quite popular and effective in cities throughout the United States. Thus, Helper and his proposal were quickly embraced, and in a matter of just a few months, Helper and his wife had moved to Roanoke.

For a few weeks prior to its formal opening, news of the Commercial Club was reported regularly in the city's newspapers. Helper knew how to promote and generate community conversation, and the ink being dedicated to his venture was proof. When the club opened, all the notable businessmen of the Roanoke Valley were present, and if not on opening night, they made certain to gain membership within the following week.

Almost daily, those who "autographed" (signed the registry book) at the Commercial Club found themselves listed in the society column of newspapers. Front-page coverage was given to the various topics of discussion at the club's weekly meetings, and the matters championed were significant. The club resolved to support a public hospital for the city and demonstrated energetic efforts to try and convince the officials of the Baltimore & Ohio Railroad to come to Roanoke. By the end of the club's first month, they trumpeted the pending arrival to the city of British and German industrialists interested in steel and iron production. They were honored guests at the club for a few days as they traveled the East Coast.

Secretary Helper could not have been more pleased. Membership was growing, the press was raving, Europeans were visiting and the club's influence was unchallenged. Helper had enlisted the aid of his cousin, Walter Murphy, of Salisbury, North Carolina, to serve as assistant secretary. The Commercial Club was from all appearances a quick and emerging success.

But there were rumors.

Helper was dropping comments to friends and associates in Roanoke that he was having marital troubles. He had, he claimed, little tolerance for his

wife of fifteen years and disparaged the institution of marriage itself. Given the mores of the times, Helper's comments were considered inappropriate at best and insulting to the rather genteel sentiments of the clientele of the Commercial Club who prided themselves on being respectable before the broader community. Helper's marriage, however, was considered a personal matter by most and was overshadowed by his skill in promoting the city's interests and cultivating its many prospects.

With the club barely open for more than a month, Helper publicly announced that he was leaving the city temporarily for surgery in New York City. Although club members were distressed by the news, they were assured by Helper that his absence would be short-lived and that his condition was not serious. Friends offered to look in on Helper's wife, who was herself in ill health.

While Helper was away, a friend of the couple read a notice in the *Philadelphia Press* as he lunched at the Commercial Club that seemed quite odd. The Philadelphia newspaper had printed among the hotel arrivals in that city the names of Mr. and Mrs. Hinton Helper. Advising Mrs. Helper of the notice, she rummaged through her husband's suits and found letters—many letters, in fact—signed "Madeline." Some of the letters even addressed Helper as "My dear husband" and solicited from him money for hotel bills, dresses and trips. Given Mrs. Helper's frail condition, her friends began contacting her husband and encouraging his immediate return.

Meanwhile, officials at the Commercial Club had inquired as to the outcome of Helper's surgery and quickly discovered that on the day he was supposedly having surgery in New York, their club secretary attended a land sale in Petersburg, Virginia, acquired a lot and spent a day or so thereafter in Richmond. Murphy, being Helper's assistant and relation, contacted him and asked for an explanation. After sending several telegrams, Helper finally responded indicating that he would be returning to Roanoke soon and wiring sixty dollars for his wife.

The *Roanoke Times*, the same newspaper that had a few weeks earlier concurred in the suggestion of having Helper's bust placed at the entrance to the Commercial Club, began making calls, including one to Helper's sister. "She denounced him in the strongest terms," the newspaper reported. Helper's associates were now insisting that he was delayed in his return to Roanoke due to his involvement with some business enterprises in Richmond. The newspaper followed up and found that Helper was not there and was not engaged in any business in that city. The Commercial Club simultaneously announced that Helper had resigned due to "ill health."

Hinton Helper was in Philadelphia with Madeline. And he had been there for several days with no intent to return to Roanoke.

Walter Murphy was quickly promoted from assistant secretary to secretary at the Commercial Club, and Mrs. Helper left for her parents' home in Savannah. With all the dirty linen of the Helpers having been publicly displayed ("A Case of Abandonment?" read one front-page headline), the Commercial Club was anxious to distance itself from Helper and a somewhat tainted reputation.

Secretary Murphy moved to enhance the Commercial Club's appeal by suggesting that billiard tables be purchased and liquor served. It would be as much a social club as a business organization. This met with the ready and announced approval of the club's board. The Commercial Club could now get on with its mission of promoting the business growth of Roanoke. Roanoke's newspapers interviewed club members, who unanimously expressed confidence in Murphy and the organization's future such that the club rebuffed an effort to be absorbed by the Real Estate Exchange.

As Roanokers enjoyed the Christmas season, the Commercial Club maintained a steady calendar of activities with meetings, visitors and public pronouncements on a variety of issues germane to the city's economy. Membership continued to grow as men enjoyed the social elements as much as the business relationships being forged. The Commercial Club began to publish pamphlets using Stone Printing to help promote Roanoke to outside investors and was regularly hosting businessmen from several surrounding states.

In early January, however, the Commercial Club was broadsided by another scandal. This one involved Secretary Murphy. He had left town. Unlike his cousin, it was not for a mistress but to escape the club's board of directors. Murphy had slipped into the Commercial Club's membership a gentleman named LaBaer, whom Murphy claimed was his college roommate. LaBaer was a pool shark who picked clean the well-liquored club members at Murphy's orchestrated billiard nights. Once club members caught on that LaBaer was skilled with the cue, the scheme came to an end, but not before Murphy and his "roommate" had pocketed significant sums. Murphy was not discouraged, however. Unbeknownst to the club's directors and most members, Murphy was organizing all-night poker in a back room at the club. These poker games were invitation only, involving men who were not members of the club, and Murphy and LaBaer racked up chips while the stack of chips belonging to everyone else "melted like an ice chip on a sidewalk in July," according to one disgruntled player. That was, until one

night's poker game went until 3:00 a.m. between Murphy and Moten Word, a young official with the Norfolk & Western. When Word had lost serious money, he charged Murphy with discarding cards after the draw. When Word's wife complained to the club president that Murphy was running a poker den out of the club's back room, Murphy's gambling operation began to unravel.

The board of directors convened a meeting and promptly dismissed Murphy. While cards were permitted, gambling was prohibited by club rules. Further, Murphy's poker games were attended by outsiders who should never have been permitted access to the club. Rumor had it that many in town were looking for Murphy—victims, no doubt, of him and LaBaer. Murphy's exit from Roanoke was under dark of night and with a slew of accounts payable.

The Roanoke Commercial Club could not survive its second scandal, especially so soon after the one involving its first secretary. The club reorganized, decided it would only hire "natives" (those already living and working in Roanoke) and changed its name to the Roanoke Board of Trade. The Roanoke Commercial Club had lasted three months.

❖✦❀✦❖

The Roanoke Board of Trade had actually existed prior to the Commercial Club but had become inactive by 1890. Thus, when the Commercial Club reconstituted itself, it effectively resurrected the board of trade. Interestingly, those involved with the board of trade, and previously with the Commercial Club, launched in 1904 the successor to both: the Roanoke Chamber of Commerce.

As for Hinton Helper and Walter Murphy, they never returned to Roanoke. Helper started going by his middle name, Alexander, following his marriage scandal. He continued traveling throughout the southeastern United States establishing several commercial clubs and gaining employment as club secretary. He eventually became an agent for the Manufacturers' Record. Helper died at his home in Baltimore, Maryland, in 1910, with his second wife at his bedside.

Walter Murphy went back to Salisbury, North Carolina, and made his name in Tar Heel politics. He served several terms in the state legislature, was a presidential elector for North Carolina in 1908 and ran unsuccessfully for Congress in 1910.

Chapter 5

MURDER AT CHRIST CHURCH

Mother's Day weekend in May 1949 was beautiful. The weather was unseasonably warm, and Roanokers were doing the customary activities for a Sunday that celebrated family. Pugh's Department store had run a special sale on "white straws," a line of ladies' hats for spring church attire, and Heironimus' beauty salon was busy that first week of May setting women's hair with the "deep wave" style. Esther Williams, Frank Sinatra and Gene Kelly were starring in *Take Me Out to the Ballgame* at the American Theater, and the news was dominated by state political primaries, baseball and the running of the Kentucky Derby.

At Christ Episcopal Church on Franklin Road, the rector Reverend Van Francis Garrett delivered a homily on the value of family and had canceled the weekly Sunday afternoon meeting of the Young People's Service League, opting instead to take his church's youth on a picnic near Callaway in Franklin County. The Women's Auxiliary at the church was looking forward to the arrival of Mrs. William Gordon of North Carolina, who was scheduled to address the group on Tuesday morning with a program entitled "Religion and Family Life." Her son was the Episcopal bishop in Alaska. Later in the week, Roanoke's Episcopal clergymen would be welcoming their bishop for the dedication ceremony of a new ministry building in the city, in which Reverend Garrett was to have a prominent role. There was much to look forward to as parishioners filed home after Sunday's service.

As mid-afternoon arrived, Reverend Garrett and his youth loaded themselves into cars and headed out for a Sunday afternoon together. The

Young People's Service League was an active group attracting not only youth from within Christ's membership but also many from the neighborhood. Christ Church's Parish House had a kitchen and dining hall with a ping-pong table and other amenities for the active youth program that normally served as its gathering place on Sunday afternoons.

About 7:15 p.m., Mrs. James Davis arrived at the church concerned that her granddaughter was not yet home. She went to the Parish House second-floor corridor, adjacent to the dining hall, and used the phone on the wall to call another parent to check if the youth group had arrived back yet. Informed that they were still out, she went back downstairs and waited. Within a half hour, the cars arrived carrying the young people, and Mrs. Davis retrieved her granddaughter and set off for home. As the youth group dispersed, the rector and a few young people remained to lock up the building. Going into the rector's office, the youths hung and straightened his vestments, which had been draped over a chair after morning worship, turned off lights in the second-floor hallway (probably left on by Mrs. Davis), locked a few doors and waved their goodbyes. It had been a good Mother's Day Sunday, or so thought Reverend Garrett.

If Mrs. Davis had looked into the dining hall, just a few feet from where she made her call, she would have seen broken dishware scattered about, turned-over chairs and tables arranged in a chaotic fashion. If the youths who had turned off the lights in that same corridor had looked into the room, they would have found the same. And if Reverend Garrett, while checking the doors and lights, had spied the dining hall, he certainly would have ventured in, bewildered as to its appearance. But no one did. There was no reason—to their knowledge, the space had been untouched since that morning. But if they had, they would have been drawn to the serving door that separated the kitchen from the dining area. The half door with a shelf was shut, but whatever had happened in the dining room had also involved the kitchen, and if any of them had looked over the door, they would have seen the bloodied, lifeless body of sixteen-year-old Dana Marie Weaver. As no one had, they all left to sleep soundly that night. But Dana Marie's mother, a school secretary, paced her home on Day Avenue wondering where her teenage daughter was as a hard rain poured outside.

It would not be until the next morning, about eight o'clock, that the church's custodian, Alexander Roland, would discover the gruesome scene—first the broken dishes, then the blood and finally the body. He immediately got in his car and drove to Reverend Garrett's home, and the reverend then phoned police. Meeting the rector and custodian at the church were

Detectives H.L. Britt and C.E. Shelor. The scene was a savage one, and the kitchen bore evidence of an intense struggle that clearly indicated Dana Marie had fought her attacker as much as she could. Her fingernails were broken, blood was smeared at various places around the kitchen, shattered dishes littered the floor and a broken glass soda bottle lay on the floor next to her body. As no money had been taken from her purse, detectives did not suspect robbery, but the position of the body and the skirt being raised above her torso suggested another motive. However, the two detectives made no hasty conclusions and methodically surveyed the crime scene and retrieved what evidence was available. City coroner Dr. Charles Irvin estimated the time of death to be about seven o'clock the evening prior, just a short time before Mrs. Davis had ascended the stairs to make her phone call. Irvin made some initial observations—a deep cut on the head, a severe bruise on the neck and large bruises on the legs, suggesting she had been kicked—but it would be a day or two before Irvin would formally conclude the cause of death was strangulation. Due to the nature of the crime, the investigation would largely be handled by commonwealth's attorney C.E. Cuddy and Detective Captain Frank Webb, who publicly stated that it was "the worst crime in this city I have ever seen."

Dana Marie Weaver was a junior at Jefferson High School, active in a variety of clubs and organizations and had just the weekend prior been in charge of the Senior Dance at Lakeside. She was blond, attractive, unassuming and regularly attended Reverend Garrett's Young People's Service League, though she was not a member of his parish. As police began that morning to investigate her activities on Mother's Day weekend, word spread that she had been murdered, and news of her death moved through the student body at Jefferson High School. The Christ Church congregation was stunned that such a violent crime had occurred in their parish house, and the Women's Auxiliary canceled its Tuesday meeting. Reverend Garrett sought to console Mrs. Murrell Weaver as the police took notes of the mother's recollections of Dana Marie's weekend outings, and the list of those to be questioned grew.

On Saturday, Dana Marie had double dated with a friend and two male students from VPI who had all gone to the Coffee Pot on Brambleton Avenue. On Sunday afternoon, according to the other girl, the four had gone for sodas at the Andrew Lewis Tavern just outside Salem. Believing the youth group was having its regular meeting that evening at Christ Church, Dana Marie had asked to be dropped off there about 6:00 p.m., not knowing that the meeting had been canceled in lieu of a picnic. According to Dana Marie's friends, that

was the last time any of them saw her. As Cuddy and Webb were interviewing Dana Marie's weekend associates on Monday afternoon, students at Jefferson High School were suspiciously eying one of their own, a junior on the wrestling team who had made some odd comments during the day as news of Dana Marie's death swept through the school; even more concerning were the scratches about his face, neck and arms. But Lee "Buddy" Scott was an Eagle Scout, athlete, volunteer YMCA swim instructor, acolyte and choir member at Christ Church. Maybe he was just unnerved, as many were that Monday, by the unexplained murder of a fellow student and that had prompted his unusual behavior. After all, he had explained away the scratches as being from poison ivy. It had been a tragic day, and everyone was on edge.

When Monday crept into night, police had no real suspects and no leads as Melville Carico penned his story for the next day's edition of the *Roanoke Times*. Tuesday's front-page banner headline would read, "Jefferson Hi Girl Slain in Kitchen of Church." But the news was already in the community, so as citizens went to bed, door locks were double checked, curtains drawn a bit tighter and slumber uneasy as many knew a killer was somewhere among them.

Tuesday morning came early for Detective Webb. Troubled that he had so little to go on, he went to the office and began reviewing his notes and the photos of the crime scene and talking it over with his police colleagues. City manager Arthur Owens phoned and told Webb that he had raised $1,100 to be given to anyone who might provide a tip leading to an arrest and conviction. Everyone was being cooperative, but Webb remained puzzled about the reason for the brutal killing of a high school student in, of all places, a church. Dr. Irvin had since ruled out rape during his autopsy, leaving Webb even more perplexed. Within a few hours, Webb would catch the break he needed. About noon, the police department received a phone call, anonymous but definitive in tone, that they should question Lee Scott, the student at Jefferson, as he might have some knowledge of the crime. The caller made no accusation—just suggested that Scott be questioned. Ironically, that very morning Scott had made the announcement as president of his homeroom that the class would collect money for flowers for Dana Marie's funeral and that Jefferson would close early on Wednesday so students could attend the service. Students began to reach in their pockets and purses for loose change as Scott moved down each row gathering what was offered. His scratched arms and face were quite visible, prompting one student to comment that Scott might be the killer. Tongue-in-cheek, Scott responded, "Yeah, I killed her. Call the police," but his dismissive tone was clearly intended to be a joke, albeit a poor one.

Wanting to interview Scott but not alert the student body, Webb notified Jefferson High's principal, and together they schemed to have Scott sent to the office by his teacher with the student believing he was on an errand. Waiting for him were Webb and assistant commonwealth's attorney Beverly Fitzpatrick. With the visible scratches and Scott's answers to a few questions, Webb and Fitzpatrick escorted Scott out a back door and into a car for the short drive to the detective's office for what would become an intense, seven-hour interrogation. Halfway through the questioning, Scott's father, Garrett, an insurance salesman, arrived, as did an uncle. Both men left the interview room in the company of a police officer some hours later, returning with a bundle of clothing and a pair of shoes that they had gotten from Scott's bedroom closet in the family's home on Second Street. The bundle contained a corduroy coat, a shirt, trousers and a new pair of tan and white saddle oxfords. As police lifted each piece from the bag, they noted what appeared to be bloodstains. Shortly after the delivery of the bag of clothing, two more officers left and returned with a paper sack they had found in an alley near Christ Episcopal containing a coffee bag from the church's kitchen and a soft drink bottle.

The clothing, the shoes, the coffee bag and the pop bottle had all been retrieved from locations offered to the police by Scott. As the items were spread before the accused and investigators, Scott's father wept uncontrollably.

Throughout the hours of questioning and the police coming and going for items as directed by Scott, students from Jefferson began amassing in the first-floor corridor of city hall wanting to know if Scott had killed Dana Marie. More continued to arrive late into the evening believing their suspicions were proving to be true. Finally, about 9:30 p.m., Webb told reporters that Lee Scott, also sixteen, was to be formally charged with the murder of Dana Marie Weaver. As the students trickled home, they could only wonder what had motivated Scott to attack and kill a classmate.

The next day, investigators would focus on that very question, but the larger community's attention was drawn to Dana Marie's funeral. Jefferson dismissed classes at 2:00 p.m. so all could attend the 4:00 p.m. service at Raleigh Court United Methodist Church. The Reverend William Watkins provided a simple service of prayer, the reading of the 23rd Psalm and the Methodist funeral liturgy. Florists had run out of flowers, there were so many tributes, and it took two Oakey Funeral Home hearses to deliver them all. The 750-seat sanctuary was standing room only, and a photographer from the *Roanoke Times* captured an image of the estimated three hundred persons standing outside on the church's portico, steps and walk unable

to get inside. The manager of Evergreen Cemetery stated that it was the largest gathering in the history of the cemetery, which had opened in 1916. The young Jefferson High School junior was interred next to her brother, Reginald, who had been killed in 1945 at Iwo Jima. For the next several days, hundreds of cars would pass through Evergreen, pausing at the floral-draped grave of Dana Marie.

While hundreds gathered at Raleigh Court Methodist, Webb was in Richmond with various pieces of evidence for testing by the state police lab, including fingerprints, Scott's clothing, the broken bottle found in the church kitchen and scrapings from underneath Dana Marie's fingernails. Webb was confident the evidence would be sufficient for a conviction. The story Scott had shared with him the day before about what had happened in Christ Church was chilling—not in the details, gruesome though they were, but because of the casual demeanor Scott had shown as he shared them.

On the day Dana Marie was buried, reporters had been allowed an opportunity to see Scott and photograph him. When Scott arrived for the brief session, he was wearing a complete tweed suit with a tie and had requested a fresh crew cut for the occasion. Combing through his hair, but not pleased with his cut, he motioned to a nearby newsman's hair and commented, "That's what I wanted." So odd was Scott's behavior that Clarence Whittaker, reporting for the *Times*, wrote, "He was enjoying the attention." Scott made few comments as his parents sat nearby.

Webb and others had shared some details of their conversations with Scott to the press, but the full account of what happened at Christ Church on Mother's Day Sunday would only surface at the trial. Of most interest to the press and public were answers Scott had given to investigators while subjected to sodium pentothal (truth serum) administered by three physicians as Webb and others recorded the conversation from an adjoining room. What Scott had offered during those sessions had not been made public. As expected, a grand jury formally indicted Scott for murder, and a trial was scheduled for June 27. The stakes were high as the commonwealth's attorney sought a conviction of first-degree murder with the death penalty, while the defense attorneys, Warren Messick and Keith Hunt, prepared their client for a courtroom drama that would make newspaper headlines across the country.

Judge Dirk A. Kuyk presided in Hustings Court as Beverly Fitzpatrick informed the jury in his opening statement of the prosecution's case and the evidence it intended to present. It was an overwhelming summary of material against Scott inclusive of Scott's own statements to investigators, evidence gathered from the crime scene, the bloodstained clothing and shoes

retrieved from Scott's bedroom closet, the broken bottle and coffee bag found with Scott's assistance and the testimony to come from fellow students at Jefferson High School. Fitzpatrick described in detail the scene discovered by Christ Church's custodian; the autopsy report that outlined the brutal, fatal attack of Dana Marie; and the lab results on the items submitted for tests—all taken together, he argued, would lead to the conclusion that Scott's action was "a willful, deliberate, and premeditated murder."

Given that Scott had officially pleaded "not guilty" to the commonwealth's charge, Messick's opening statement came as a surprise when, after a litany about Scott's activities as a scout, athlete and church member, the defense attorney announced that Scott had indeed killed Dana Marie, but it was manslaughter, not murder. It was, Messick stated, "the unintentional killing of a person in the heat of the moment."

Testifying for the prosecution on the first day was the city coroner, who asserted that Dana Marie had died of suffocation due to sustained pressure on her neck "exerted for at least five minutes." Irvin explained the nature of Dana Marie's bruises and wounds as jurors looked over police photographs of her body taken at the crime scene, images Messick had tried unsuccessfully to exclude. There was a head wound one and a half inches in length that caused severe bleeding, a wound under the chin and another under the right collarbone, abrasions on the hands, broken fingernails and bruising on the upper thighs. The wounds on the neck were, according to Irvin, caused by tremendous pressure applied by the fingers of her attacker.

Webb followed Irvin and described for the jurors the scene in the parish house kitchen, and then came an official with the state medical examiner's office who testified that bloody hair fibers found on Scott's clothing matched those of Dana Marie and that blood samples taken from Scott's clothing and shoes also matched that of the deceased.

As other law enforcement officials offered similar testimony to Webb's, Fitzpatrick turned to Dana Marie's friends to begin reconstructing her activities on Mother's Day Sunday. She had been out that afternoon with William Johnson, Ben Richardson and Cynthia Parr, all of South Roanoke, for a drive, returning about 5:30 p.m. to drop off Cynthia at her church and then taking Dana Marie to Christ Episcopal. A few other witnesses testified, and the prosecution rested its case.

The witness most wanted to hear took the stand on July 2. Lee "Buddy" Scott was preceded by a parade of character witnesses, mostly friends from school and church who portrayed the young man as being courteous and friendly. So when Scott began to testify, Messick sought to guide his

client's remarks in such a manner as to convince the jury that his killing of a fellow student was not the calculated and willful act being alleged by the prosecution. "Something just came over me," Scott told the jury, when Dana Marie made "slurring remarks" about Scott's friend Jimmy Webb. Scott said he had arrived at Christ Episcopal about 5:30 p.m., the same time as Dana Marie, having made arrangements to meet a close friend, Fred Bradley, to play ping-pong and then go to a movie. Not seeing Bradley, he struck up a conversation with Dana Marie, and the two went into the church kitchen to get soft drinks. The conversation became heated as Dana Marie made comments about Scott's friend, and then, he said, "something just came over me, and I struck her with the bottle I had in my hand. She swung at me either with her fist or the bottle," and then Scott said the two of them fell to the floor, where he tried to prevent her from hitting him. As he held her down by the neck, "she tried to claw my eyes out," Scott said. Then the struggle ended. "I felt sick and scared. I got more sick when I saw all the blood on her and on the floor and on me."

Scott told the court that he left the church and headed for Bradley's home, laying the bottle that was still in his hand on the ground in an alley, and then decided to go to his own house instead. Under Cuddy's cross-examination, Scott was pressed to explain why Irvin's autopsy found that the strangulation pressure had exceeded five minutes; why there were other bruises on the body, especially the legs; why the victim's tight-fitting skirt had been pulled up over her head; why he had made odd comments about her death to students at the high school; and why he had denied even being at the church on that afternoon when first questioned by police. Scott was unable to offer any explanations. Cuddy also raised one final question about that evening, which was Scott's call to a friend after he arrived back home. He had washed off his hands and face, discarded the bottle, hid his clothes in the back of his closet and tried to clean his saddle oxfords of blood. After doing all of this, Scott then called a friend, inviting him over to play a game—a phone conversation that the friend had earlier described as being normal and friendly. Again, Scott could not explain his unassuming demeanor given what he had just done.

In passionate closing statements, both Cuddy and Messick did their best to persuade the jury. "Every so often," argued Cuddy, "is born an individual with a desire deep down in his heart to do things which men cannot explain…Lee fits this description." Scott's parents sat directly behind their son in the courtroom when Messick stood to make his final plea. Mr. Scott wept, wiping his eyes with a handkerchief, and Mrs. Scott looked down. They had been there every day,

listening, crying and wondering. Messick had no choice but to plead for mercy. "You are not trying a gangster. You are not trying a mobster. You are trying a boy...For one mistake by one who has lived at the foot of the Cross, would you convict him of first-degree murder?"

Of all the summation statements, Fitzpatrick's may have been the most compelling. Pointing to the clock, he stood in silence as five minutes ticked away. "Gentlemen, you can see he had plenty of time to think and reflect, if he had turned her loose any second, she would be alive today."

On July 2, the jury deliberated for two hours and ten minutes and returned a guilty verdict with a punishment of ninety-nine years in prison. Scott showed no emotion when the verdict was shared, but on his way back to his cell, he commented to one of the jailers, "Well, what do you think of that? How many books do you think I can read in that time?"

The editorial board of the *Roanoke Times* called the verdict "just, fair, and warranted." The trial of Lee Goode "Buddy" Scott had lasted for nearly a week, but the crime, investigation and indictment of a young Jefferson High School student had captured the attention of Roanokers for an entire summer. The last reported comment from Scott came as he was being led past a city police sergeant: "I've got ninety-eight more Fourths to spend in jail."

—◆◆◆◆◆—

Lee Scott did not spend ninety-eight Fourths in jail. He was sent to serve out his sentence in a state facility in Richmond from which he was paroled after serving approximately twenty years. He left Virginia and moved west, married, raised a family and led a seemingly productive life. He died in the mid-1990s.

Chapter 6

THE BLACK CARDINALS

There were the Black Cardinals, the Springwood Giants, the Norfolk & Western Stars, the Roanoke All-Stars, the Royal Giants, the West End Athletics, the Northeast Blue Sox, the Peach Hill Giants and the Roanoke Dodgers at various times between the 1920s and early 1960s. These teams composed Roanoke's version of Negro League baseball.

The Black Cardinals grew out of the Roanoke All-Stars, which in turn had emerged from the Norfolk & Western Stars. The Cardinals formed shortly after the Second World War, hitting their stride in the late '40s and early '50s. Home field was Springwood Park located behind what is now Lincoln Terrace Elementary School, and summer Sunday afternoons were for baseball. Admission to the games ranged from twenty-five to thirty cents during their run, and crowds would arrive early, having to stand or sit on blankets for the games. The absence of bleachers and the charge to see the game sent some to "Panic Hill" just beyond the outfield to spy the game from a distance. Some spectators wagered on the games, a few sipped moonshine and many rode special buses from downtown to the games. Baseball was a center of black social life.

The Cardinals played hard in the summer's heat and arose early the next morning to work at the Norfolk & Western, where a foreman, Roy Gable, acted as both supervisor and team recruiter. When a job opened at the N&W's roundhouse on Sixteenth Street, Gable would first ask an applicant, "Can you play ball?"

The Cardinals often traveled, playing teams in Lynchburg, Norfolk, Greensboro, Bedford and Portsmouth. Some local games were played at

Salem or Maher Field, especially if lights were required for the occasional night game. The Cardinals occupied the last years of Roanoke's thirty-year golden age of black baseball, which had begun in the 1930s with what is believed to have been the first semipro black baseball team, the Springwood Giants.

Of all the opponents to take the field against the Cardinals, none were as well received as the famous teams of the Negro League that came to Roanoke on their way to Cuba to play post-season baseball: the Kansas City Monarchs, the Homestead Grays, the Pittsburgh Crawfords, the Atlanta Black Crackers, the Baltimore Elite Grays and the Indianapolis Clowns. With them came such players as Satchel Paige, Joe Black and Josh Gibson. The Cardinals, and other local teams, played them tight, sometimes even winning—with the hope of some men to have their talent recognized by a Negro League team and be given an opportunity to rise to their ranks. Two did.

Macajah Marchand "Mack" Eggleston was born in Roanoke in 1896 and, by the 1920s, was catching for the Baltimore Black Sox, but his love for the game had been cultivated through sandlot ball in Roanoke before leaving for West Virginia in 1915. In 1919, he broke into the Negro League with the Dayton Marcos and would spend nearly two decades in the league as a player and coach. Eggleston never returned to Roanoke to live, though he may have traveled through as a member of the 1936 Baltimore Elites during his final season.

Larry LeGrande played in the final years of the Negro League, concluding his baseball career in 1960 with a minor-league team in Florida affiliated with the New York Yankees. The youngest of nine children, LeGrande grew up in the Pinkard Court section of Roanoke County and had made the starting roster of the Memphis Red Sox in 1957. By the time he had gotten to Florida, the Yankees had their first black major-league player, Elston Howard, and apparently they did not want others. LeGrande was cut from their minor-league roster in 1960, even though he had led the Florida State League in hitting. He traveled with Satchel Paige's All-Stars for the next few years, eventually returning to his home community and working for General Electric.

The Cardinals, like many teams preceding them, had such raw talent that, if times had been different, some players might have had an opportunity to play professionally. Baseball in Springwood Park was so good that by the early 1950s, the Black Cardinals were often drawing better crowds than Roanoke's white minor-league team, the Red Sox. When Jackie Robinson finally broke Major League Baseball's color barrier in 1947, some thought

their opportunity had finally arrived only to realize racism still gripped the game. Henry Craighead was twenty in 1947 and made an approach to try out with the Roanoke Red Sox. He was informed by its manager, Clarke Wray, that he would consider Craighead once the Boston Red Sox integrated. Sadly, the Boston Red Sox were the last Major League Baseball team to integrate, not doing so until 1959. The first black Roanoker to break into the major leagues was Al Holland, who made the 1977 roster of the San Francisco Giants.

Official records of Roanoke's rich history of black baseball are nonexistent as the games were rarely reported in the city's newspapers. The stories, the names and the standout plays reside only in the memories of those who took the field or were fortunate enough to have purchased a twenty-five-cent ticket. As for the Roanoke Black Cardinals, only one player survives, Alphonzo Holland, at age ninety-six. Tall, erect and bespectacled, Holland recalls the late nights on the road, the small pay and the sheer joy of the game. One night, the Cardinals had played the team in Greensboro with the offer of the team getting either a flat $100 to come or a split of the gate, with 60 percent going to the winner. The Cardinals decided to take the $100 figuring the gate would be much less, only to find that the Greensboro team had lights, bleachers and a standing-room-only crowd. The Cardinals won and got back home to spread around the fee among its players, and Holland recalls that by the time they paid Roanoke Hardware for the new uniforms, reimbursed those who had driven for their gas and the costs for food going and coming, each got less than a dollar. When asked about batting against Satchel Paige, the corners of Holland's mouth turn up, and a smile melts across his face: "He struck me out."

A long stretch of grass occupies what was once the ball diamond of Springwood Park, where the men of the Cardinals and other teams—Jim "Bull" Jones, brothers Henry and Mack Craighead, John Thomas "Pops" Payne, Lee Calloway, David Phillips, Jess Smith, Dolphus Jones, Bob Jefferson, Chappie Simms, Early "Lefty" Edwards, George Brown, George Hampton, Fred Rice, Malcolm Williams and Quince Irving, among many others—played baseball on hot, summer Sunday afternoons for nothing more than the pleasure of the game. And if fortunate, they competed against the barnstorming teams of the Negro League, staring down Satchel Paige under lights at Salem or Maher Field and chasing hits by the Kansas City Monarchs.

When Monday morning came, the Cardinals were back at the railroad, usually the roundhouse, earning livings, talking baseball and knowing that no matter the course of the week, Sunday was coming.

The home field of the Cardinals remains part of a city park, though its baseball heritage is not marked and it no longer contains a baseball diamond. Mr. Holland could not recall the specific year of the Cardinals' last season—though it was probably around 1950—other than to note that with integration, all-black baseball teams and leagues eventually faded away. Darrell J. Howard, an author and baseball historian, wrote in his book, *Sunday Coming: Black Baseball in Virginia*, "Based on a scattered record of wins and their playing schedule from season to season the Black Cardinals probably rank as the fourth best team in the history of Virginia's black baseball teams prior to the era of integration."

NUMBER 167

Oscar Scott Woody was logged in as "Number 167" when the former Roanoker's body was found bobbing in the frigid North Atlantic by the CM *Mackay-Bennett*. Wearing a cork life jacket, Woody was clad in a gray pinstripe suit, and on his person were a pocket watch and fob, two fountain pens, letters to his wife, a pocketknife, cuff links, his wedding ring, keys and a chain. So badly decomposed was his corpse that the crew of the *Mackay-Bennett* buried him at sea after saving a few personal effects that conveyed his identity.

Oscar Woody was known to many Roanokers for his work ethic and affable personality, having worked in the railway post office in Roanoke for seven years in the 1890s. He was a man prone to meticulous organizational skills, made friends quickly and impressed his co-workers such that the then-bachelor was a regular dinner guest in their homes.

Raised near Roxboro, North Carolina, Woody had come to Roanoke with the rail postal service, having already spent a few years handling the railway mail service for trains running between the city and Winston-Salem, North Carolina. To be stationed in Roanoke given the ever-increasing volume of mail being transported by the Roanoke & Southern Railway put him in the city at a time when Roanoke's population and commerce were growing at an enormous rate, giving rise to its "Magic City" moniker. Woody was one of the many young men venturing to Roanoke for jobs, but his maturity and dependability were quickly recognized by the postal administration. His rounded face, light hair, dapper appearance and marital eligibility caught

the attention of several young women in the city, but Woody did not return any affection with seriousness.

He initially boarded at the St. James Hotel, just a few blocks from the railway post office headquarters of the Roanoke & Southern. Woody ran opposite of W.P. Firey on the railway, and the two became close friends. Firey and the older clerks saw in the young man potential as they worked alongside him for six years. It came as no surprise when Woody was asked by the postal administration to move to Washington, D.C., and clerk in the railway office servicing the Southern Railway and the mail that was running between the nation's capital and Greensboro, North Carolina. After he left Roanoke, the society columns in the Roanoke newspapers regularly listed him as being in the city "visiting friends."

It was when Woody moved to the Southern Railway mail offices in Fairfax County that Miss Leela Bullard of Dallas, Texas, caught his eye. They were married in Washington in 1911. He was forty, and she was thirty-one. They had become engaged in 1910, and that same year the postal administration had promoted Woody out of the Third Division of the Railway Mail System and into the Sea Post, a position that carried prestige and a salary of $1,000. Such plum jobs were highly competitive and valued, but Woody's job performance in Roanoke and Washington had been noticed by his superiors and thusly rewarded.

While the Woodys would maintain their home in Clifton, Virginia, he would travel occasionally to New York City to serve transatlantic steamers. One such opportunity was the April 2, 1912 voyage of the SS *Kaiser Wilhelm der Grosse* to Plymouth, England. The voyage afforded Woody the usual perks of traveling abroad, a small stipend in addition to his salary for the foreign stay and second-class meals and accommodations aboard the ship. Woody must have thought on such occasions of someday being able to bring Leela with him. Or he may have thought of his friends in Roanoke and what they would think of his newfound position, travels and maritime accommodations. At his age, he faced many years of Sea Post adventure.

When the *der Grosse* arrived in Plymouth, Woody handled the transfer of the mail with the same attention and care that had marked his career. He lodged in Plymouth and took in the city that night. Unknown to Woody, assistant supervisor of foreign mails Edwin Sands had noted that Woody's forty-first birthday was approaching on April 15. Rather than return Woody to New York on one of the many steamers that would be leaving Plymouth during the course of the week, he decided to give Woody the prized opportunity to serve as a postal clerk aboard England's premier Royal Mail Ship, the *Titanic*.

Its maiden voyage departed on April 10 from Southampton. To receive such an appointment was another indication of the postal service's confidence in Woody. In the span of a decade, Woody had moved from the railway mail service office in Roanoke to the Sea Post and would now traverse the Atlantic on the *Titanic*. One can only wonder what thoughts raced through Woody's mind as he received his room key at the Parkers Hotel in Southampton, where he spent the night before his departure.

The *Titanic* carried 3,364 sacks of mail for Woody and four other clerks to sort during the voyage. Woody was teamed with two other American clerks, John March and William Gwinn, and two British mail clerks, John Smith and James Williamson. The men hit it off, sharing sleeping quarters originally in third class. Complaining of the late-night dancing and music of those in steerage, the clerks were moved to quieter accommodations by the second night and given their own private dining room. A photo taken on the *Titanic* shows Woody and his fellow clerks in the mail sorting room, smiling for the camera.

Each man had a facing slip stamped with his name that would be attached to each mail sack, thereby identifying the clerk who had stamped and sorted that mail should there be any mistakes. The first few days of the voyage passed quietly for the clerks, with passengers often bringing by additional mail to be sorted and delivered upon reaching New York.

The clerks decided to give a special party for Woody in honor of his birthday on the fourteenth as the next day would bring their arrival in New York. They were enjoying the late-night birthday dinner and probably discussing their having processed some 400,000 pieces of mail when they, like others, felt a slight shift. Perhaps a bit bewildered, the clerks returned to their conversation.

The mailroom was in the bowels of the ship at G deck and soon began taking on water. The clerks were warned by a bedroom steward, Albert Theissinger, to get to the mail. Accompanied by the steward, the men raced to find the sorting room filling with seawater. Theissinger, Woody and the clerks quickly began moving the sacks of registered mail to the upper C deck, but within minutes Theissinger pleaded for them to leave the mail and get higher in the ship. Theissinger, who survived, later described the last known sighting of Woody and his co-workers: "I urged them to leave their work. They shook their heads and continued at their work. It might have been an inrush of water that cut off their escape, or it may have been the explosion. I saw them no more." When Theissinger left, Woody was standing in two feet of icy water.

How much longer Woody and the others worked to save the mail is not known, but they did eventually make their way to an upper deck, where Woody secured a life jacket. The *Titanic* slipped below the surface of the North Atlantic in the early morning hours of April 15. Oscar Scott Woody died on his birthday.

It would be two days before Woody's friends and family would get word that his name was not among those who survived. Newspapers reported that his wife and mother were placed under medical care, while his brother traveled to New York to retrieve what personal effects had been recovered. Co-workers in Roanoke were deeply saddened and recalled a friend who made a quick and longstanding impression on them. W.P. Firey was informed by a reporter of Woody's death when he stepped off a train in Winston-Salem and was heading for lunch. Firey, who had worked closest with Woody, was stunned, not knowing that his friend had been on the *Titanic*: "He was one of the best men I ever saw."

A week after the sinking, the White Star Line sent the *Mackay-Bennett* to salvage whatever was floating in the Atlantic. Woody's lifeless body was clinging to an ice float. When his remains were lifted from the frigid water, his pockets contained facing slips for his mail sacks and a twenty-four-inch metal chain with a mailbag key attached to his belt. The crew of the ship retrieved what was necessary, detailed their findings, removed the life vest and then sent Woody back into the Atlantic. His formal burial at sea was on April 24. Items recovered from his body were put in a cloth sack marked "No. 167."

Leela was given the pouch by her brother-in-law and kept Woody's effects for the remainder of her life. She never remarried. Woody had joined the local Masonic lodge in Fairfax, and upon Leela's death, the pouch's contents were donated to the Masons. The postmaster general authorized a payment of $2,000 to Leela and the spouses of the two other clerks on the *Titanic*. Leela sued the White Star Line for $50,000, but like most of the other *Titanic* litigants, she did not prevail.

Roanokers, like the rest of the nation, followed the *Titanic*'s sinking through the front pages of the newspapers. The Sunday following the tragedy, the city's congregations were reported to have sung "Nearer My God to Thee," as this was what the ship's band was rumored to have played as it slipped into the sea. The notice of Woody's death, "Former Roanoker Lost on *Titanic*," had graced the front page of the *Roanoke Evening-World* two days prior to the Christian Sabbath; thus, as some sang the hymn that Sunday, Oscar Woody was remembered.

———◆◈◆———

Today, the postal items recovered from Woody's body remain the only *Titanic* postal materials to have been salvaged. Woody's name was inscribed on a metal plaque that adorned the High Post Office in Southampton, England, honoring him and his four co-workers. The plaque has since been moved to the city's civic center. The federal post office in Roxboro, North Carolina, was named for him by President George H.W. Bush. Woody's pocket watch, mail keys and facing slips were exhibited at the Smithsonian in 2001. The mail keys, pocketknife and other personal items donated to the Masonic Lodge by Leela were sold a few years ago at auction on behalf of the Masons to raise funds for philanthropic causes.

Oscar Woody was not Roanoke's only connection to the *Titanic* tragedy. John Borland Thayer, who was serving on the board of directors of the Norfolk & Western Railway and was a regular visitor to Roanoke, perished aboard as well, though his wife and son survived. Further, $12,500 of Roanoke Gas and Water Company bonds that had been consigned in London and were to be paid upon delivery were being carried by the *Titanic*.

FISTFIGHT AT SHENANDOAH LIFE

Roanoke's remarkable population boom in the 1890s and early 1900s caught the attention of Colonel John T. Boone of Long Island, New York. Boone was a professional "organizer" or promoter, one of many such men in his time who traveled to growing towns and counties selling the idea of raising capital for new, get-rich-quick schemes. The typical modus operandus was to organize some new venture by selling stock, knowing a hefty commission would be earned. The promoter never troubled himself with the actual development of the business venture, leaving that to others. Instead, his main talent was to exude affluence, be perceived as knowledgeable and have the gift for easy conversation. Boone was such a man.

Boone's specialty was stock insurance companies, raising local interest and then undertaking the sale of stock necessary to capitalize a new company prior to its actually conducting business. "Boone," it was said, "could sell a widow a suit with two pairs of pants to bury her husband in." Stock insurance companies, much like banking, after the turn of the twentieth century were largely unregulated affairs, providing men like Boone the flexibility they needed to operate, gliding around whatever minor statutes or regulations a state might have.

Boone had organized several life insurance companies in the South, including the Southland Life Insurance Company in Dallas, Texas, and the Pan-American Life Insurance Company in New Orleans, Louisiana. Prior to these ventures, he had been inspector general for the New York Life Insurance Company for over thirty years. He knew his way around the

business. But not all had been convinced by his pitches to start new ones. He had failed to launch ventures in Norfolk and Lynchburg, but those setbacks did not deter him from coming to Roanoke in 1914. Boone knew how to make money, and Roanoke was ripe. The presence of the railroad and the accompanying industrial and agricultural wealth amassed by many had not bypassed the keen eye of Boone.

Boone settled in at the Jefferson Apartments on the corner of Jefferson Street and Mountain Avenue. The apartment structure with its bay windows was a very reputable address and one that overlooked the city. Such a residence conveyed to others that Boone was a man of means and taste, living within a few blocks of some of the wealthiest citizens of the city.

Boone knew that for his proposal of organizing a stock insurance company to succeed, he would need a leading businessman to lend his name and some treasure to the effort. It would be on that person's shoulders that the eventual operation of the company would rest, as Boone would serve as a kind of fiscal agent selling the stock to raise the capital. With this kind of scenario, such a venture had the ring of authenticity, legitimacy and, most important, profitability.

The man Boone sought first was J.B. Fishburn, as the Fishburns controlled the National Exchange Bank, the daily newspaper and many other interests in the community. Fishburn was a patriarchal figure on the streets of Roanoke, a man the young aspired to become and whose name would be an immediate attraction to Boone's venture. Boone could only imagine the commission he would earn on the sale of stock for something that had Fishburn behind it. But Fishburn was a cautious man whose reputation had been built on careful, conservative considerations when it came to affairs of finance. Thus, Fishburn declined Boone's offer.

Boone's next move was to approach a man whose reputation and ambition were not much beneath Fishburn's. He contacted Robert Henderson Angell. Angell had run away from home in Callaway at the age of sixteen and got his first job as a hand on the farm of Gideon Turner in the Cave Spring section of Roanoke County, earning twelve dollars per month. He attended school and was offered a janitor position at the high school in Salem. At eighteen, he moved to Roanoke and obtained a job in a brickyard, always saving his money and eventually making his way into varied, small business enterprises. By the time Boone had arrived, Angell, now forty-six, was a respected member of Roanoke's wealthiest and most prominent business class, a truly self-made man with a wife, family and large home at 218 Mountain Avenue. Angell's interests involved the Colonial National Bank,

Robert Angell, a founder of
Shenandoah Life Insurance
Company. *Collection of the author.*

Liberty Trust Company, Roanoke Iron Works and several manufacturing companies. Angell's neat appearance of a receding hairline and well-trimmed mustache belied a man who had risen from poverty, forgone higher education and knew the physical and psychological rigors required for success. Thus, on a cool Sunday afternoon in the late winter of 1914, Angell, accompanied by his young son, Frank, sat in Boone's parlor just three blocks from his own home and factually bore into being the Shenandoah Life Insurance Company. Angell's cigar smoke mixed with the aroma of Boone's meerschaum pipe, and the two conversed with an ease and warmth that had been almost immediate. Boone laid out the plan with a litany of facts and figures, dropping the names of personalities across several states with whom he had worked and impressing Angell with his research on Roanoke and its future. Both envisioned the possibilities, and no one else in the city was launching a homegrown life insurance company.

As Angell walked home with his son, uphill along Mountain Avenue, he surely rolled over in his mind all that Boone had shared, and one can only wonder if he considered with any concerned manner the quality of Boone himself. Angell loved Roanoke. The city had been good to him, and he desired only its best. His personal ambitions were wed to those he had for Roanoke,

and Angell was a charitable man giving generously to the city's orphanages, among whose ranks he felt kinship. A life insurance company would provide another business opportunity for Roanoke to grow both in wealth and reputation and could help not only those whose resided in the mansions he walked past but also those at the neediest level of Roanoke's society.

Boone could watch Angell and his son walk home from his apartment window. As he did, he knew he had the right man. Angell was imminently qualified in the public mind as one capable of sound financial judgment, competency and leadership. Boone's commissions were all but ensured.

The first step Angell took, under the guiding hand of Boone, was to assemble a group of local businessmen for a conference with Boone. The agreement was that Boone would operate as the Colonial Organization Corporation, promoting the sale of fifty thousand shares of stock at ten dollars' par value, though the first series would be priced at twenty dollars to accelerate capitalization. Boone's commission on a twenty-dollar share of stock was to be five dollars—a rather high premium. When sufficient funds were raised, Boone's corporation would hand over the funds to the Shenandoah Life Insurance Company, and Boone and his agents would exit, leaving the local luminaries to conduct the respectable enterprise of a life insurance company.

Shenandoah Life Insurance Company was chartered on December 23, 1914, by the State Corporation Commission. Those who lent their names to the venture were Angell; Dr. J.H. Dunkley, physician; J.T. Bandy, a real estate developer; and Waller Judson Henson, prominent attorney and a director of Roanoke's First National Bank. The goal was to commence operation within twelve months.

By early 1915, other notable men from Roanoke and southwest Virginia had agreed to serve as directors, officers and large shareholders. They included a future governor, bank presidents, developers and a congressman. The first incorporators' meeting was held on June 23 at 116 West Campbell Avenue. The meeting was attended by only a few, and the office, being rented for $150 per month, consisted of some old desks and chairs left by a previous tenant in a space that was as dirty as it was unlit. Boone's and Angell's determination and enthusiasm, however, were undiminished, and the establishment was soon occupied by Boone and his agents plying their skills in the selling of stock. Hammond Printing and Lithographing of Roanoke had printed the stock on heavy paper with a pastoral scene of land swept into distant mountains with the company's gold-leaf seal. The stock itself conveyed security. And Hammond had agreed to the job

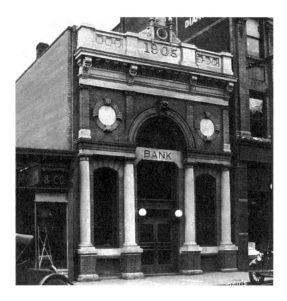

An old bank building at 116 West Campbell Avenue served as the first office when Shenandoah Life opened for business in 1916. *Collection of the author.*

in exchange for Boone's promise of company stock—a promise on which he failed to deliver.

As Boone and his men sold stock, Angell and others were busy organizing the company, spending long hours researching policies, insurance practices, methods of investing and procedures. Their labor was intensive, often frustrating and never mediocre. With Angell at the helm, all were giving their best.

The same could not be said about Boone and his men. The first to notice was the company's secretary, William Andrews, who sensed danger and shared his concerns with Angell. The two men began keeping a keener eye on Boone's agents and had noticed a significant drop in sales as compared to the first few months. Sales reports were missing, others contained only partial information and Boone could offer little, if any, explanation. Andrews and Angell decided they needed to investigate, but hiring private detectives to pry into the practices of their own agents, talking to customers and prospects, would be extremely damaging during the very sensitive birthing stage of the company. Thus, the two men decided to go a different route and hired a man with whom Andrews was familiar, a stenographer at the Norfolk & Western Railway by the name of Fred C. Collings. Collings had been around the railroad for many years, working with payroll shipments and dealing with many who had succumbed to their base natures when delivering payroll, ferreting them out and handing them over to his superiors. He was just the

man Andrews and Angell needed to conduct an investigation with discretion, causing little disturbance but effectively getting at the truth.

Within a few weeks, Collings was reporting to Andrews and Angell, and their suspicions were proven right. Boone and his men were selling stock, but not in accord with company policy. They were selling fractional shares and shares to persons who had no intention of paying for them, bartering and trading shares, altering shares and taking other liberties. The most popular selling device employed by Boone was the promise of a choice price for life insurance once the writing of policies was begun. Some stock buyers were even promised company positions from financial agents and general counsels to medical examiners.

The news of Boone's antics, sluggish finances and the effort needed to contain the debacle from moving beyond the company's circle of directors was taking its toll on Angell and Andrews. Andrews's health was failing, he felt, in large part to the stress of the insurance company, and he was granted a month's leave of absence whereupon Andrews retreated to a mountain spa resort to nurse his recovery. Angell, meanwhile, continued his duties as president but found disgruntled stockholders and frustrated directors often appearing in his office at the Central Manufacturing Company demanding explanations and assurances. This occurred to such an extent that Angell could barely function as head of the manufacturing enterprise that was located just a few blocks away from the Shenandoah Life Insurance Company office. All of this was compounded by various directors seeking to protect their own business or political reputations from any potential scandal. Thus, Angell took the unusual step of writing stock subscription blanks himself outlining the terms and thereby discouraging any innovative additions by Boone's agents.

By month's end, Andrews had returned from his mountain respite only to find that matters had worsened. Boone and his agents had failed to take seriously the reprimands of Angell and others and had, in fact, found even more devious means by which to sell stock. Licensed only to conduct business in Virginia, Boone's Colonial Organization Corporation had sold stock in at least six states using its own forms and usually on a deferred payment basis. Pressure mounted. Stockholders wanted dividends, the public wanted the launch of the company and the actual writing of policies and others were looking to be hired.

By September, as if matters could not become worse, Andrews learned that Boone's agents were now selling stock for almost eight dollars a share above its approved list price, pocketing the margin. Collings continued to

bird dog Boone and his men, and his regular reports were alarming. Angell and Andrews were doing everything to control the chaos and maintain a proper business reputation for the fledgling company befitting their own reputations. Such a valiant effort had limited success. John B. Neill, an officer of the Bank of Clarke County in Berryville, wrote a scathing epistle to Angell advising that the stock agents had "deceived" some very influential businessmen in the area. He listed his grievances, supplied names and demanded adjustments. Neill concluded by strongly suggesting that Angell send a responsible representative to the area to "Do something." A similar report came in from a bank official in Danville.

By early October, the normally affable Angell was seething, keeping Boone in his sights. Boone and his men had pocketed thousands in commissions, legal and otherwise, while Angell had worked as company president without pay. The following week, Angell took an out-of-state trip related to his other businesses and learned further how his company was being exploited. He gained the name of one particular agent who was selling stock for an illicit profit. Back in Roanoke, Angell made certain to confront the agent at Shenandoah's office.

The imagination can certainly conjure the mood of Angell when he walked into the office and saw the agent sitting behind a desk. Angell was brutal in his candor as he laid out for the agent his knowledge of the agent's activity and his opinion of the man. While Angell spoke, the agent slowly moved his hand to the desk drawer and withdrew a pistol, pointed it at the company president and threatened to pull the trigger. Weeks, even months, of frustration, hard work, long hours and complete disdain for Boone and his men coursed through Angell's five-foot, ten-inch frame. His starched collar could not contain the rush of blood to his face as he looked at the agent and the gun amid insults and insubordination. Knowing not whether the agent would actually fire his weapon, Angell threw a right uppercut that shattered the agent's jaw, propelled him backward against the wall and dropped him unconscious to the floor. The accomplished and composed Angell had had enough. The agent was carried to Lewis-Gale Hospital and spent seven weeks recovering from Angell's punch.

A week later, on October 16, Angell convened a meeting of the directors and promptly dismissed Boone, all agreeing not to litigate but to rectify any of Boone's activities with stockholders through their own personal wealth. This action avoided public attention, and in time, the directors would recover their losses. Such was the birth of the Shenandoah Life Insurance Company.

Boone retired to his Jefferson Apartments residence, packed his bags and took a train to New York. His agents did the same, but one agent heading north could not resist pawning some remaining shares of Shenandoah stock left in his coat pocket to thirty-six unsuspecting Catholic priests as he left the state. Shaking their heads in disgust, Angell and Andrews honored their purchases.

<hr />

The Shenandoah Life Insurance Company emerged from its challenging beginnings to become a major corporate citizen of the Roanoke Valley. When it finally opened for business on February 1, 1916, and began issuing policies, it received only a small mention at the bottom of page seven in the local newspaper. J.B. Fishburn, the man who had declined Boone's overture, purchased the very first policy and later policy numbers 10,000, 20,000, 30,000, 50,000, 60,000 and 100,000. Robert "Bob" Angell remained connected to Shenandoah Life for the rest of his life. He died on November 12, 1933, and at the time of his death he had pledged everything he owned as security for eight thousand shares of Shenandoah Holding Company, a stock reclamation company for Shenandoah Life. As for Colonel John Boone, Shenandoah Life Insurance Company was his last business venture as he collapsed and died at his summer home in Neponsit, Long Island, on January 24, 1916. His son had died just a few days earlier of pneumonia in St. Louis, Missouri. They were both laid to rest in Greenwood Cemetery, Brooklyn, following a double funeral.

MARRIED OR NOT MARRIED?

Charles Howard was a man accustomed to getting what he wanted. As manager of the Louisiana State Lottery, Howard had developed a reputation for rewarding friends and remembering enemies. Proclaimed as the "Louisiana Lottery King," Howard was integral to the controversial and corrupt state lottery that was, at best, an early means for Louisiana to recover financially from the Civil War and, at worst, a scheme that deprived citizens of their earnings in a lottery that was plagued by fixed drawings, limited payouts and Howard's "Black Book."

Howard's Black Book was reputed to have contained the long list of bribed public officials and kept detailed notes of those who had sought to harm the lottery machine. Millions of dollars in lottery profits were managed by Howard during the twenty-five-year franchise from 1868 to 1894. While John Morris was the public figurehead, a man not above reproach by any means, it was Howard who kept the scorecard, lined the pockets of state politicians and harvested hefty sums for himself.

Howard was a man who wielded influence and made or broke many men, political and otherwise, in postwar Louisiana. In Howard's shadow was his son, Frank, who in his mid-twenties began escorting around New Orleans a widow six years his senior. The Lottery King strongly objected to his son's amorous relationship and demanded it be ended, even offering his son $50,000 as an inducement to do so. The expectation that his son would acquiesce was certainly ensured given Howard's penchant for barking orders and manipulating the lives, ambitions and fortunes of so many in and around New Orleans.

The actions taken by young Frank would prove grist for the rumor mill of New Orleans high society, make headlines in Louisiana and New York and drag the sleepy village of Big Lick into the spotlight of an investigation that one prominent newspaper would call "a tale of romantic corruption such as has heretofore been unequaled in Southern society." The year was 1880.

The object of Frank's affection was the widow Mrs. Gray Doswell, formerly Emma C. Pike. The Doswell and Pike families were prominent, reputable members of New Orleans society, in contrast to Howard, whose dirty money had allowed him to crowbar his way into the opera halls and gallant balls of New Orleans. Nonetheless, the Pikes' and Howards' paths often crossed with the social calendar of activities in Louisiana's capital city.

When Frank and Emma's courtship officially commenced is unknown, but by the summer of 1879 the two were often seen together in the city attending shows, charity events, operas and dances. To those who knew Emma and, by extension, her family, the notion that she would keep company with a member of the Howard clan raised many eyebrows, not least of which were those of her own mother and brother. Emma's father, William, had died a few years earlier. However, Emma seemed quite happy with Frank, and being a widow with two children, finding a man of means was not to be diminished. Further, Frank did not have the reputation of his belligerent father, and so the two allowed their romance to deepen despite warnings from Emma's family and confidants. As time progressed, many began to wonder if Frank and Emma were going to marry, so when a notice appeared in the New Orleans city newspapers in late November 1880, their curiosity was satisfied: "HOWARD-DOSWELL, On Thursday, September 25, 1879, by C.H. Wilson, Esq., Justice of the Peace, at Big Lick, Roanoke County, Va., Frank T. Howard to Emma C. Doswell."

Interest was piqued and gossip aroused, not by the marriage notice itself, but because the families had withheld the information for over a year. Given the penchant of New Orleans society for the timely communication of such occasions, this was most odd. Most were certainly willing to forgive the faux pas, but what appeared a few days later in the New Orleans papers grabbed the city's attention: "A CARD, the Statement in the public press that I was married, at any time or place, is untrue. I am not married and never have been married. Frank T. Howard."

Two prominent families were now swept up in a swirl of contradiction trumpeted in Louisiana's leading newspapers. The *Louisiana Capitolan* and the *New Orleans State* each sent a bevy of reporters to find and interview the parties involved. Most sought after was Frank Howard, in whose

name the latest notice had been placed, but when reporters arrived at his New Orleans office, they were told he had not been in the city for several days. Some even suggested he might have left the country. The intrigue deepened. Only when Emma Doswell's family was contacted did a story emerge that would cause editors to declare on their front pages, "A Scandal Sensation." As newspapers around the state and in the South entertained their readers with what was a personal embarrassment for Emma Doswell and a public disgrace for Frank Howard, one Florida newspaper declared, "Social circles in New Orleans are just now undergoing a sort of tidal wave of excitement from a choice bit of scandal which has been unearthed and the vile author exposed." Even the *New York Sun* ran a front-page headline on December 5—"Married or Not Married?"—about the "strange matrimonial entanglements."

It took reporters only a few days to piece together the curious events of the Howard-Doswell affair.

Frank had called on Emma at her mother's home and began to take Emma out driving and to social functions, much to the opposition of his father. Knowing this, Frank decided to proceed with the relationship quietly. After two years, Emma's family became impatient, wondering if an engagement was not to be and advising her to look for another suitor.

In September 1879, Emma, her mother and her brother, Dr. George Pike, left New Orleans for Salem, Virginia, to spend the early fall there at a springs resort. Hearing of their travels, Frank decided to use the occasion and the out-of-state locale as the opportunity to wed Emma, avoiding the scorn of the Lottery King.

All four got rooms at the same Salem hotel, and on one afternoon, Frank and Emma went on a buggy ride, something they had done with regularity in New Orleans. Once they were out of Salem, Frank picked up a man whom he introduced to Emma as Mr. C.H. Wilson, a justice of the peace. Together the three then continued on to Big Lick, where Frank and Emma were married. Entrusted into Emma's care was the marriage certificate, as she knew her husband could not keep the marriage document lest his father discover, at an inopportune time, their marriage. The newlyweds quickly returned to the Salem hotel, telling no one what had transpired, and each kept their own rooms for the rest of the stay. The marriage remained a secret even in New Orleans as Frank and Emma maintained separate homes but courted as usual, with Emma continuing to be called "Mrs. Doswell." It seemed both had made good with the prevailing circumstances. Frank was still single in the eyes of his domineering father, but Emma, a devout

Catholic, could be "intimate" with the man she had married and the promise of a public declaration of their marriage forthcoming.

Only in the spring of 1880, while on a family trip to Nashville, did the arrangement begin to unravel. Emma, once again in the company of her family, was questioned about her relations with Frank as he, too, was in Nashville. To protect her honor, Emma produced the marriage certificate and shared details about the secret ceremony in Big Lick the previous fall. Frank confirmed the story, and the two took up residence together in a Nashville hotel. They soon went to Atlanta and made a home in an apartment there.

Back in New Orleans, Emma's brother eyed Frank with suspicion. The good doctor was a bit more wise and worldly than his sister and demanded to see the actual marriage certificate. He could only wonder, Why the secrecy? Why no public declaration? Frank left Emma in Atlanta and traveled to New Orleans for the sole purpose of convincing his brother-in-law of the legitimacy of his marriage—or so he said.

Dr. Pike wasted no time in sending for Frank upon his arrival and demanded of him the certificate. The Lottery King's shadow must have loomed large over his son, for Frank claimed that Emma had it in Atlanta. Pike was furious. Knowing he had to do something, Frank conceded to write a statement that read, "I certify that myself and Emma C. Doswell, née Pike, were married on September 25, 1879, at Big Lick, Roanoke County, Va., by C.H. Wilson, justice of the peace from Salem." Frank claimed he had business in New York and left New Orleans after a few days, but only after telling Pike that he and Emma would be remarried in the Catholic Church per her family's wishes.

Pike, feeling he had protected his sister's reputation with Frank's handwritten statement, was convinced by friends to run notice of the marriage in the New Orleans papers, which he did. This became the source of the first notice pertaining to the Howard-Doswell affair. But Pike was not completely satisfied. He simply disliked and could not trust the Howards, so Pike telegraphed the clerk of Roanoke County to inquire about justice of the peace Mr. C.H. Wilson. The reply came with a crushing force. There was no such person. In fact, no one by that name even lived in the county, much less held such a position. "No such man as C.H. Wilson in this county. Marriages by Justices of the peace not allowed under the law of this State." Pike realized his sister had been the victim of a cruel design and immediately left for Atlanta to retrieve her.

As Frank was en route to New York by train and Pike was heading to Atlanta, the Louisiana Lottery King was comfortably ensconced in his

second home in Dobbs Ferry, a suburb of New York City, a place he often visited to tend to his varied business interests. When a telegraph reached him congratulating him on his son's marriage to Emma Doswell, the Lottery King roared. As his assistants scurried to determine the cause for such a telegraph, the King was informed of the notice that had appeared in several Louisiana newspapers.

A reporter for the *New York Sun* asked for comment, and the elder Howard was none too glad to give his assessment: "I have had two men down in Virginia getting proof that I shall take with me to carry the matter into the courts. The fact is it was a case of the old Southern shotgun policy. They got the boy in a room and, fearing that they would shoot him, he signed a paper saying that he was married. There never was a ceremony and he never was married. They thought I was rich and wanted to get my money, but they got hold of the wrong man." The Lottery King continued barking, "I am too old to be scared, and when I get to New Orleans there will be music. That boy is only 26-years-old and the woman is 32. I told Pike two years ago that he must stop his sister from going with my son...It was all a conspiracy, and if they don't give me that document they forced him to sign, I'll show the thing up in courts."

While the New York newspapers dogged the elder Howard for comment, Emma was approached by a reporter from the *Atlanta Constitution*. "Do you believe you were married or imposed upon?" the reporter asked.

"Oh, we were married. There is no doubt about it. There was no trick. The card you see denying it is not Frank's work. His father is the cause of this trouble. He has objected to the match all along," Emma responded.

"Do you believe your marriage to Howard was bona fide?"

Emma was adamant, stamping her foot on her carpet. "I know it was!" As Emma began sobbing, she demanded the reporter leave her apartment but not before telling him that she would be leaving for New Orleans the next day. The story that appeared was quite sympathetic to Emma. "Mrs. Howard—as she insists upon calling herself—is decidedly a lady of refinement and culture...she has an air which is very attractive. She is a blonde whose elegance of manner should make any man proud to call her his wife."

The Howard-Doswell affair was making front pages in major newspapers. The *Washington Post*, *Richmond Daily Dispatch*, *Atlanta Constitution* and *New York Times* were enticing their readers with the tawdry news of the scandal.

Charles Howard delivered on his promise. He had demanded that his son print the public retraction notice on the marriage, and the Howards

filed a $90,000 defamation suit in the New Orleans court against Pike for his submission of the marriage notice without Frank's permission. For all of the Howards' bravado, they were losing in the court of public opinion. The *Louisiana Democrat* summed up the matter in its December 8 edition. "The son, to evade his father's wrath, sets up the plea that he was never married, and it turns out that the ceremony…was a sham, and done to deceive a trusting and confiding woman. Public sentiment is very much against young Howard." Further, the officers of the New Orleans Club alerted the press that they were launching their own investigation into the actions of Frank Howard, as he was a member, and would take "appropriate action."

As erroneous reports circulated that Frank had left the country, he and Emma were trying to make amends. Frank conceded that he had concocted a mock marriage and that "C.H. Wilson" was an employee of his and not a justice of the peace from Big Lick. Frank and Emma found themselves in the vice grip of anger from both sides of their respective families. The Lottery King demanded his son abandon Emma and her "shotgun-toting" relatives, and Dr. Pike accused Frank of being a fraud and robbing his sister of her honor. While Howard and Pike stared each other down, Frank and Emma desperately tried to repair their romance.

After a few days in New Orleans, Charles Howard realized that he could not prevail. The press, the public and Howard's closest confidants were arrayed against his son. The court case was dropped, and the families retreated into private, having had their dirty linen aired in the most public of ways as fodder for every major newspaper from Louisiana to New York. Though the gossip would continue about the Howard-Doswell affair that gripped New Orleans society in the winter of 1880 for many years, there appeared a brief notice in the January 1, 1881 *Louisiana Capitolan*: "The Howard-Doswell imbroglio was finally settled Sunday last, at Bay St. Louis, where Mr. Frank T. Howard was married to Mrs. Emma C. Doswell at the Church of the Lady of the Gulf, by the Rev. Father Henry LeDuc." They had married on Christmas Day.

Lottery King Charles Howard died tragically from injuries sustained in a buggy accident in 1885. His daughter established the Howard Memorial Library in New Orleans in his honor. In time, the library merged with another to become the Howard-Tilton Library at Tulane University. His fortune was equally divided amongst his four children, and he had appointed Frank as

his executor, suggesting a repair to the father-son relationship. As for Frank and Emma, they circulated in New Orleans society, traveled extensively and gave generously to various Louisiana charities. Emma died in New Orleans in 1898. Frank would remarry—without scandal—and live until 1911. His legacy was creating the Confederate Museum in New Orleans in 1891 that still operates today.

Chapter 10

THE DROUGHT

At 10:00 p.m. on Tuesday, October 31, 1916, Roanoke officially went dry. Though national Prohibition was three years away, Virginians had voted to become a dry state, overriding the slew of local options that had allowed places such as Roanoke to be wet. In fact, Roanoke was wetter than most. Many surrounding jurisdictions were already dry, leading to a proliferation of new saloons for Roanoke and a steady stream of outsiders to patronize them.

The wets and the drys had been at each other in Roanoke for many years. The drys mostly included Protestant clergy and women. Roanoke had active chapters of the Woman's Christian Temperance Union, the Anti-Saloon League and the Prohibition Party all dating to the 1890s. The wets included businessmen and the working class. Business leaders feared a dry city would be bad for attracting commerce, not to mention the breweries and saloons operating within the city limits. As for saloons, there were plenty. The 1915 Roanoke City Directory listed twenty-eight along Salem Avenue and Second Street with names like Dutch Kitchen, Klondyke, Monticello, the Palm Saloon, the Panama, Stag, Union, Diamond & Moses and Concordia. There was constant tension between the two sides, ranging from adopting local prohibition ordinances to blue laws. All of that came to an end in September 1916, when citizens of the commonwealth voted overwhelmingly to make Virginia the nineteenth dry state in the Union.

The ordinance that had been adopted called for the sale of all beer, wine and liquor to end at 10:00 p.m. on the last day of October. To prepare for the

The Capitol Saloon, formerly the Raleigh Café, at 23 Salem Avenue, Southwest, around 1913. *History Museum of Western Virginia.*

funeral of John Barleycorn, all police officers in the city were called in and put on patrol; parents were encouraged to keep their children home after dark, ending Halloween early; and the Norfolk & Western gave all employees their paychecks two days early so that liquor could be bought before the deadline. The law stated that while liquor could not be sold during state prohibition, it did not criminalize its private consumption. Thus, saloons prepared for the run on their supplies as persons bought what they could to take home for storage in basements, attics, garages and, for some, burial in their backyards.

The *Roanoke Times* described the last night before what became known as "The Drought" with a eulogy: "Old John Barleycorn of Roanoke laid down his life last night. A dying king may have no friends, but John Barleycorn was accompanied to the grave by a stream of mourners who would have reached from the uttermost point of the West End yards to Bonsack."

The pro-prohibition *Roanoke Evening-World* chose to celebrate the night by coupling it with its election opinion favoring Democrat Woodrow Wilson over Republican Charles Evan Hughes:

Yesterday we parted with Mr. Booze
This time next week goes Mr. Hughes.
No more booze,
No more Hughes,
Tata blues.
Things will happen as we choose;
Your timely going we excuse;
Goodbye Booze,
Goodbye Hughes,
Tata blues!

Saloonkeepers were hardly writing poems. The last night in Roanoke before The Drought was chaotic as a rush ensued to get the last available supplies. One man drove in forty miles from his farm and loaded his vehicle with beer and whiskey. As he pulled away, a tire broke away from his vehicle. He and others could only watch as beer and whiskey flooded his car and poured into the street. Amid his eruption of foul language, he managed to salvage a half pint of Turkey gin.

A customer exited a saloon on Salem Avenue with two loaded suitcases and went into another establishment for one last drink with a friend. When it came time to depart, he discovered that others had emptied the suitcases while he drank.

Another man bragged to his friends that he had purchased a barrel of whiskey the week before and buried it at his farm. When his friends asked if the barrel was worm proof, he rushed off to disinter it.

The N&W depot was overwhelmed with passengers from dry counties coming to Roanoke. Empty suitcases were brought back full, some dragging them through the street as they arrived to catch a departing train.

The city police force made so many arrests for public drunkenness that the jail became full by mid-afternoon.

The breweries and wholesalers shipped that morning whatever supply they had to other states.

Retailers began charging three and four times their average price, as customers lied to one another about where to find the best deal in the hopes of thinning a line.

Churchgoers and even stalwart prohibitionists were spied with a suitcase or two and claimed they were purchasing for medicinal reasons.

Businessmen jostled and laughed with the working class, and the occasion was likened to Mardi Gras in New Orleans, as even the teetotaling curious ventured over to Salem Avenue to witness a historic moment.

Dillard's Liquor Store was located at 110 Salem Avenue, Southeast, when this image was taken in 1907. *Virginia Room, Roanoke Public Library.*

The scene was made even more surreal as a number of partiers heading out for Halloween festivities at hotels and private homes stopped and made their way along Salem Avenue costumed as witches and clowns.

Saloons and wholesale dealers served thousands. Customers could not get what they ordered but gladly drank whatever was served. Packing boxes, kegs, barrels and bottles lined the floors of local watering holes, and Salem Avenue was described as "a scene of devastation."

Some saloons tried to make the best of it, hanging signs in their windows poking fun at prohibition:

"This is the last week. Next week will be weaker."

"After November I don't tell what you wished you had. I'll know it anyway."

"Don't tell me that you want it for the old lady—she's got hers. How about yours?"

"If you don't believe we sell good liquor cheap watch the price of cheap whiskey after Tuesday."

"You can have all we have left after Tuesday night."

"Best wishes for a happy dry year!"

"Preparedness is the word. Watch yourself and don't get caught."

One saloon ran dry that afternoon and hung a sign that read, "Good night."

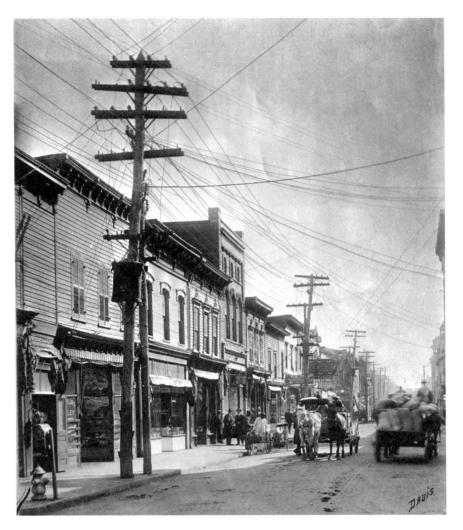

Salem Avenue as it looked in 1910 in this George Davis photograph, looking east from Henry Street. *Virginia Room, Roanoke Public Library.*

Alcohol and beer sales in Roanoke on the last day of legal liquor were estimated to have topped $100,000. And at the stroke of ten on October 31, thirty-six retail and shipping dealers shut their doors. The white-coated bartenders at the hotels and clubs swabbed their bars as porters dimmed the lights. The Drought had begun.

The next morning, Salem Avenue and a few other formerly wet sections of the city were abandoned. Saloonkeepers arrived late afternoon with knives

and soap to scrape clean their windows of ads for spirits, a requirement of the state prohibition act. Trucks lined Salem Avenue as they were loaded with tables, chairs and fixtures, while a few passersby looked into the windows and stalls of now-empty bar halls. To Let signs were hung, and Salem Avenue was, for the first time in Roanoke's history, eerily quiet.

While many were sleeping off the effects of the Halloween night revelry, others were looking forward to a temperance celebration. The city's drys led primarily by Mayor Charles Broun had planned a rally for Sunday afternoon at the Jefferson Theater. Every temperance organization in the city, including the Ministers' Conference, was in support of the program that included an address from the mayor and others and a tableau presented by twenty young ladies and fifty children. The drama was entitled, "The Children's Tribute to the Nineteen Prohibition States." Mayor Broun had prepared his remarks around the theme "The Relation of the City of Roanoke to the New Law," and the chief of police, Charles Hamilton, was a listed speaker as well. Admission was free, and the Jefferson Theater was standing room only.

Colonel J.D. Johnston acted as emcee and began the program by having the audience stand and sing, "Praise God from Whom All Blessings Flow," which was followed by an invocation from the Reverend J.H. Halthis. Mayor Broun stirred the crowd by pledging to strictly enforce the law of prohibition in the city. After a few more speakers, the tableau was presented with children parading down the theater aisles and onto the stage with black cloaks that they threw off in a dramatic fashion symbolizing the casting off of liquor in Virginia. The audience rose to their feet and thundered applause.

Prohibition ended on December 5, 1933, with the repeal of the Eighteenth Amendment. On October 3 of that year, Virginia voters overwhelmingly voted for repeal. In Roanoke, the vote was 3,928 for repeal and 2,128 against. Virginia voters simultaneously rejected state prohibition should national Prohibition fail. Roanokers voted down state prohibition 4,036 to 2,156.

Chapter 11

CHILDREN OF THE MILL

Mamie Witt had worked in the Roanoke Cotton Mill for a few years. She was the oldest of five children and walked to work from her family's house in Norwich. Mamie worked six days a week, twelve to fourteen hours a day. She was a spinner with little education. Her meager wages helped support the family. Mamie was twelve.

Ronald Webb lived near Mamie and was a doffer in the mill. He, too, was twelve. And there was Frank Robinson, a doffer and sweeper. Frank was seven.

The owners of the Roanoke Cotton Mill lived within walking distance of the Witts, Webbs and Robinsons in grand homes lining Patterson Avenue and surrounding West End and Highland Park, but it can be safely assumed that they never saw them. Mamie, Ronald and Frank were part of an invisible group, sharing bedrooms with siblings in cramped company-built mill houses in Norwich, a section located on the south side of the Roanoke River just beyond the bounds of Roanoke City. Norwich had been named for the Norwich Lock Company, a short-lived enterprise that had established a presence there in 1891. The cotton mill moved into the abandoned lock company's brick plant in 1901.

Calls for Roanoke to have a cotton mill began around the turn of the century with leading businessmen of the city asserting that a cotton enterprise would boost the local economy and reputation of Roanoke to outside interests. The Roanoke Board of Trade, a forerunner of the chamber of commerce, spearheaded the cause, and within a few years a milling operation was in place.

In the January 31, 1907 edition of the *American Wool and Cotton Reporter* appeared a description of the mill: "The mill is pleasantly located on the banks of the Roanoke River between two low lying hills...The mill is the pioneer twine mill of Virginia. The company recently began the manufacture of polished twine. This is the only mill situated in the gateway of southwestern Virginia." According to the report, the mill was producing one- to thirty-ply cotton of any color that could be put up on cones, tubes, skeins or balls. The two-story structure with skylights was under the "clever management" of T.J. McNeely. The *Reporter* concluded with a rather skewed view of the workers and their condition: "It is no wonder that this mill has been successfully operated and that its force of intelligent operatives gathered from the nearby mountain regions are perfectly satisfied with their lot."

A photographer's images a few years later provided a much different portrayal. And never mind that in 1902 there were calls to investigate the cotton mill for the labor abuses of the women and children working there.

The "intelligent operatives" who were "satisfied with their lot" betrayed an elitist attitude that had been inflicted on the early residents of Norwich who had indeed come from outlying rural areas in search of a better life during the birth of Roanoke's industrial boom. In 1893, an early proponent of building a cotton mill suggested it could provide employment to "a class of people who have heretofore not found suitable work." The translation was the poor, little-educated residents of Norwich whose savings and lives had been harshly manipulated by numerous business ventures in that area that had provided little wage and no sustained presence.

J.J. Cox, manager of the St. James Hotel in Roanoke, took a *Roanoke Times* reporter with him into Norwich in December 1896. Cox had been so moved by what he had seen that his "tours" were to convince Roanokers to consider Norwich's families as objects for Christmas charity. The reporter with Cox described what he saw: "If ever there was a place cursed with wretchedness, poverty and suffering it is here...the starved, pinched faces of the poverty stricken women and children are there to speak for themselves." After visiting the home of one family, the reporter wrote, "They were living, no not living, but existing in poverty, filth and wretchedness that are hard to contemplate without seeing for yourself." Families in Norwich had little furniture, small amounts of food and poorly constructed homes heated with wood scavenged from the riverbank.

The men who brought the cotton mill to Norwich claimed it was for philanthropic purposes more than an opportunity to earn capital. Yet these very same men adamantly opposed in the ensuing years the very things that could have provided the children and families of Norwich opportunity

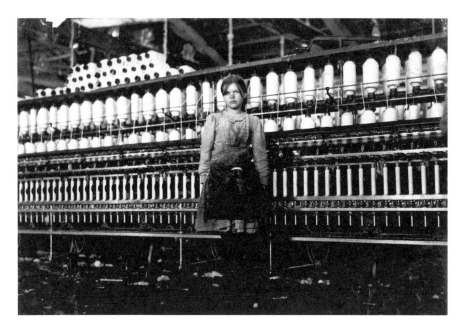

Mamie Witt, age twelve, stands beside a spinning machine in the Roanoke Cotton Mill in 1911. *Virginia Room, Roanoke Public Library.*

and stability—notably, public education for the children and a regulated work environment.

Recognizing that cheap labor could be easily gained from Norwich's children, the owners of Roanoke Cotton Mill began employing them from the beginning of operations, and by decade's end, Mamie, Ronald, Frank and thirty other children were on the payroll.

When child labor abolitionists tried to introduce labor regulations for passage in the Virginia legislature such that children under age ten should not be employed and those under age sixteen should have at least three months of education per year, the Roanoke Board of Trade adamantly opposed such measures, with the investors in Roanoke's cotton mill being influential members of the board at that time. Industrial interests in the state celebrated the legislation's defeat. The *Roanoke Times* joined the chorus, "Bread is more important than schooling" and opined that the end of child labor would be the end of industries. Thus, for Mamie, Ronald and Frank, conditions did not improve, and an opportunity for compulsory education evaporated. But there was movement at the national level that involved a little-known schoolteacher and his camera.

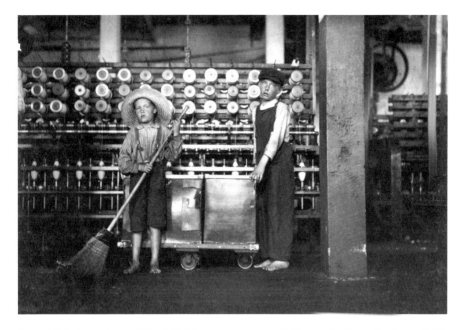

Ronald Webb, twelve, and Frank Robinson, seven, were doffers at the Roanoke Cotton Mill in 1911. *Virginia Room, Roanoke Public Library.*

In 1902, the National Child Labor Committee (NCLC) was birthed by a group of reform-minded women, clergy and political progressives who were passionate about alleviating the working conditions of child laborers across the United States. Impoverished, malnourished and uneducated, thousands of children worked in canneries, mills, fisheries, mines and sweatshops throughout the United States from New England to the Deep South. Years of testifying before Congress, lobbying, letter writing and marching had yielded little as the NCLC found its efforts rebuffed at every turn by industries whose money and political muscle carried far more clout with Congress as they claimed child laborers were necessary for their commercial success and provided wages necessary for the children and their families to survive.

Few took notice of the child labor reform movement as it languished in obscurity and irrelevance for several years, but the movement's leadership was committed to its cause. In 1907, the NCLC decided to take a different tact with Congress and the nation by documenting the living and working conditions of child laborers. To do so required hiring a skilled photographer to capture on film what was occurring. The man hired was Lewis W. Hine, an industrial photographer working in New York City.

A sociologist as well as photographer, Hine began in 1908 journeying across the United States to large cities and small towns using his lens for social reform. He took photographs of seven-year-olds working in a cannery in Maine and young girls at a cotton mill in Biloxi, Mississippi. There were the boys at the Ewan Breaker of the Pennsylvania Coal Company in South Pittson with dirtied overalls and blackened faces, and the five-year-olds working a Colorado beet field. A five-year-old and an eleven-year-old were collecting bags to be mended on the streets of Boston, Massachusetts, and a gang of ten-year-old boys worked at the cigarette factory in Danville, Virginia. Hine would spend seven years and take over five thousand images of children working. Often, Hine would take a photograph of a single child, his or her eyes staring blankly into the camera.

Regardless of the nature of their work, the lives of Hine's subjects were much the same—six-day workweeks, twelve- to fourteen-hour days, squalid living conditions and no chance for an education. Their substandard wages hardly befitted the manual, sometimes crippling labor the children performed. The child laborer was expendable, and many died of work-related injuries or disease due to the lack of sanitary living conditions.

Hine's lens was capturing the underbelly of American industry, what politicians at all levels had willfully chosen to ignore by failing to legislate the slightest regulation against the use of children.

In May 1911, Hine was drawn to Roanoke, not as a layover to his next stop but as an integral part of his photographic montage of child laborers. He pointed his camera inside the Roanoke Cotton Mill in Norwich. Hine took about a dozen images, and for a few of them, Mamie, Ronald and Frank were his subjects.

Hine's lens captured Frank with his broom and straw hat alongside Ronald. The barefoot boys stare blankly back at Hine, perhaps having their photograph taken for the very first time.

Young Mamie is shown next to the spinning machine. Dressed in a draped cotton shirt, her tired eyes glance to the side.

For many of the dozen images Hine took at the Roanoke Cotton Mill, he provided a brief description of his subject matter, conveying a sense of what he found.

"I counted seven apparently under the age of fourteen and three under twelve years old," Hine wrote of a photograph of a group of boys working as doffers and spinners.

"She is twelve years old and helps support an able-bodied, dependent father."

"Said fourteen years old, but it is doubtful."

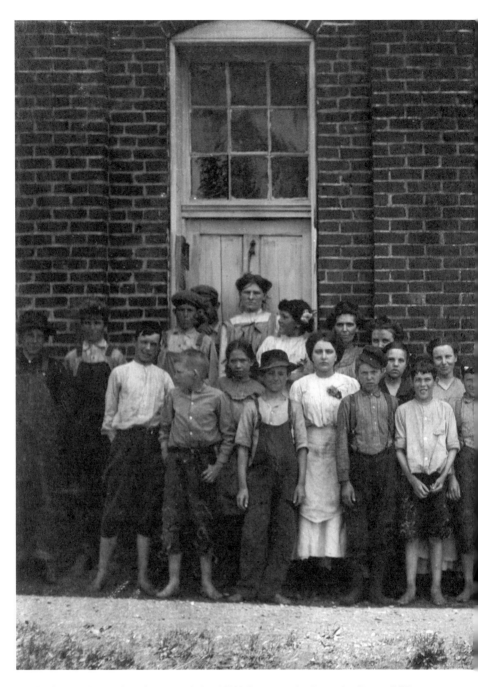

Lewis Hine took this photo in 1911 of the child laborers at the Roanoke Cotton Mill located in Norwich. *Virginia Room, Roanoke Public Library.*

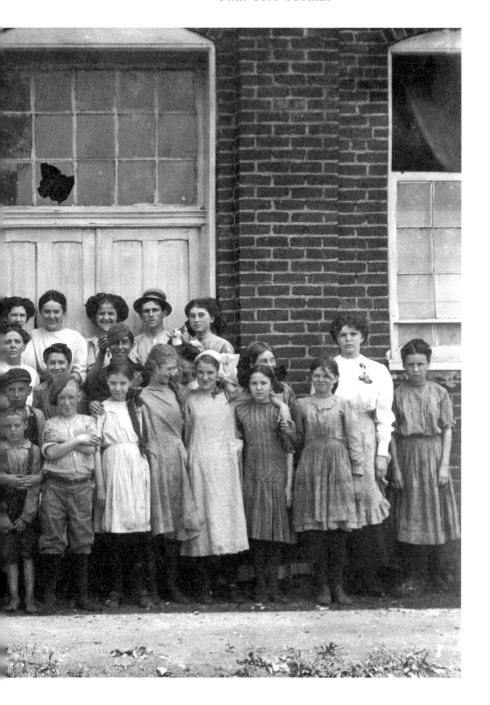

Hine took an image of a family standing on their back porch and wrote, "He is apparently working on the railroad but his three oldest children (oldest being 12), here work in the Roanoke Cotton Mill...House is poorly kept. Mother would not be in photo."

In a photograph of the Norwich neighborhood with the cotton mill in the background, one can see the tenement houses. Hine noted, "Housing conditions at the Roanoke Cotton Mill are not very good. Houses are run down, not well kept."

Childhood had eluded Ronald, Frank and Mamie, as well as many others who were Roanoke's mill children. Yet Hine had given them a dignified part in his campaign. The photographer kept moving south and eventually handed over his collection of five thousand images to the NCLC for its ongoing efforts to abolish child labor in the United States.

Those efforts would ultimately prove fruitful, but too late for Mamie, Ronald and Frank. By the time child labor was legally abolished by Congress in 1938, Mamie and Ronald were thirty-nine and Frank was thirty-four. For thirty more years after Hine visited Roanoke, child laborers were used at the cotton mill, diminishing only in the mid-1930s when desperate Depression-era men needed work.

What might not have ever been known to Mamie, Ronald and Frank (or their descendants) is that the photographs of them in the Roanoke Cotton Mill were preserved and became part of the Hine Collection in the Library of Congress.

———◆❖◆———

Lewis Hine died in 1940, just two years after the passage of the Federal Fair Labor Standards Act that effectively ended child labor in this country. Much like his subjects, Hine died poor and obscure. Years after his death, the industrial photographs taken by Hine became highly valued both for their sociological legacy and as true photographic art. His most famous images are of men constructing the Empire State Building.

The Roanoke Cotton Mill later became the Maurice Twine Mill. A large brick edifice, it was razed in the 1960s.

The images Hine took of Norwich's child laborers are part of the Library of Congress's photographic archives. At the urging of this author, the Roanoke Public Library Foundation acquired the Norwich prints from the LOC, and they are now in the collection of historic photographs in the Main Library's Virginia Room.

Chapter 12

A Boy Named Mark

It all started at a USO dance in Fort Worth, Texas, in 1953. David, a staff sergeant in the U.S. Air Force, could not take his eyes off Diane, a student nurse. The courtship was brief before David and Diane were married, and nine to ten months later, the couple celebrated the birth of their first child, a son named Mark.

Discharged from the military, David decided to use his GI Bill benefits to pursue a degree at Purdue University in Indiana, so the young family left Forth Worth and headed north. Like most couples of that era, Diane was the dutiful wife working part time as a nurse to support her husband while also tending to Mark. Times were tight, but the young couple managed to make ends meet as David matriculated through Purdue's engineering program. Upon graduation, he landed a job with American Oil Company in its credit department, and the family relocated to Decatur, Georgia.

By all outside appearances, the family was a model of middle-class domestic life, but inside the home tensions began to escalate. David and Diane argued, and there was physical abuse. Compounding matters, Diane worried about her toddler son. He had a habit of rocking back and forth, almost trance-like. The family's pediatrician reassured her that his rocking motions were nothing to worry about and that in time Mark would outgrow them. Diane doted on her son, finding in him an outlet for her nurturing, attentive side as David's hours at the office lengthened and the distance between them grew.

David and Diane remained in Decatur for two years until Amoco transferred David to its division office in Roanoke. Wanting to remain close

to the office, located at 200 South Jefferson Street, David rented a house for his family at 2124 Crystal Spring Avenue. To those in the South Roanoke neighborhood, it was the old Dawson home, having been previously occupied by A.R. Dawson and his wife for some thirty years before both passed away. For Mark, now a first-grader, this was a formative time, and playing along the tree-lined streets of South Roanoke provided his first vivid memories of childhood. It was 1961.

Diane enrolled Mark at Crystal Spring Elementary School. Decades later, Mark recounted their South Roanoke home with its "big spooky attic" and some of his school classmates. The home bordered the lawn of First Presbyterian Church, whose grass spread beneath sprawling oaks. It was here that Mark often played by himself. Diane had given birth to her and David's second child, a daughter named Jill, and so her time with Mark was diminished by her need to attend to Mark's newborn sister.

Mark was befriended by First Presbyterian's pastor, the Reverend Dr. Walker B. Healy, who noticed Mark frequently playing around the church yard. He tasked Mark with keeping a vigilant eye on the block. "I took the job very seriously. I would walk around the church grounds and keep an eye on the place. It was like a security guard would do. I thought of myself as the guardian of this church, and I would walk around it every day to see that everything was all right," Mark would later recall. In the mind of a first-grade boy, this was an important assignment.

At school, Mark encountered difficulty making and keeping friends. Perhaps his family's moving three times in Mark's first seven years created such difficulty. Whatever the case, the young boy seemed to have thoughts and ideations that differentiated him from his playmates.

On one occasion, Mark was walking home after school with a friend when they came upon a cat that had been hit by a car. Noticing the blood and the protruding entrails, the boys were mesmerized by the sight. Mark remarked, "Oh, isn't that too bad?" His friend interpreted Mark's comment to be smart and lighthearted. "God saw that!" the friend retorted. "God has this book in heaven and every time you do something wrong, He makes a little mark on it. If you get too many marks, you're going to hell!"

Mark, the church guardian, ran home crying to his mother, the comments of his friend searing through his mind. He was now on God's bad side, and punishment was looming. Diane managed to soothe her troubled son. Not being religious herself, Diane nevertheless assured Mark that God was not mad at him and he should not take to heart what his friend had said. But he could not dismiss thoughts about death.

Sometime later, Mark was pulling his wagon along Crystal Spring Avenue and noticed men carrying a coffin into the Presbyterian Church. People were crying, and Mark sat in his wagon entranced by the unfolding scene. He had never seen a coffin, had never been to a funeral and did not know until later that the black box contained a dead body. It was all new to him. "It was fascinating, seeing this great emotional turmoil and not knowing what was happening," Mark remembered.

Then there was the turtle shell he found in the dirt. Turning it over in his hands, he wondered what had become of the shell's occupant. Blowing the dirt away, he caressed it, cleaning it as he examined the bleached hull for several minutes and thought, "What had happened to the life that had been there? This had to be death. But what did it mean?"

Mark became intrigued by death, his young mind fixated on these images and responses to death all discovered within the small terrain of where he played and went to school. To others, this may have appeared odd, but to Mark, so much by himself, his thoughts gravitated in that direction.

Mark also recalled that his childhood in South Roanoke was marked by obsessive grudges. Mark got in an argument with one of his Crystal Spring classmates, and so enraged by his friend's actions, Mark went home and drew wanted posters against his friend. With his dad's hammer and nails, Mark went through the neighborhood nailing his posters to trees. Mark would later claim that such impulses were born of a deep sense of alienation and overwhelming anger—feelings he could not dismiss.

Whatever might have been happening at school was nothing in comparison to the relationship Mark was witnessing between his parents. Diane would often run through the home in torn clothes screaming for Mark to come to her as she fled from David. The young boy would sometimes hear his mother crying behind the locked bathroom door. Mark developed an intense rage toward his father compounded by the frustration that he was helpless to defend his mother. The yelling, scenes of spousal abuse and the general emotional detachment shown by David toward his son caused Mark to take solace outside the home, sitting in the green, oak-shaded grass of First Presbyterian. It may have been in just such a moment that the church's pastor initially extended friendship to Mark.

Mark's childhood forced him to internalize his anger, which would manifest itself in occasional outbursts of rage toward friends and especially his father. Mark's biographer later summarized, "Finding himself unaccepted by other children and unable to face the responsibilities of the bitter adult world that he felt his parents were thrusting upon him, Mark

turned for answers and revenge to his own imagination." Mark's ideations created a world of what he called "Little People." And within that world, Mark found solace as the line between reality and imagination blurred. When angry, Mark would kill the Little People, shooting them or blowing up their houses. When needing acceptance, the Little People would forgive him and even bathe him in their adoration.

David and Diane did not remain long in Roanoke before Amoco transferred David once again. The family had stayed for just a little more than two years, long enough to be listed in the 1962 city directory. Mark had completed both first and second grades at Crystal Spring Elementary School and then was faced with the familiar task of making new friends in a new place. The oak trees of First Presbyterian, the "spooky attic" of the Dawson home and those first images of death would linger in Mark's memory as his connections to Roanoke, but his world, both real and imagined, after Roanoke continued its descent. And the role of the Little People grew.

Mark's parents eventually divorced, and Mark moved through adolescence and into young adulthood, marrying, dabbling in fringe religion and being drawn to the protest culture of late 1960s and early '70s. He dropped out of college and went through various jobs. Mark traveled around the world and then married his travel agent in 1979. There was much that most would consider normal about Mark's life, but he was mentally ill. The Little People told him things and made demands of him. There were voices and menacing gargoyles during his psychotic breaks, but detachment from family and friends hindered him from being properly diagnosed and treated. Given more time, perhaps Mark could have been helped.

"The death of a man who sang and played guitar overshadows the news from Poland, Iran and Washington tonight," was how Walter Cronkite opened the broadcast of the CBS *Evening News* on December 9, 1980. Mark had thrust himself into the national and international limelight. The "guardian" of First Presbyterian and boyhood classmate of those who were at Crystal Spring Elementary in the early 1960s was Mark David Chapman. And on the evening of December 8, Mark shot and killed a man he had been stalking when his prey stepped out of a taxi at the Dakota on West Seventy-second Street in New York City. The celebrity musician had made public statements that troubled Mark, and the Little People demanded that Mark act. John Lennon collapsed in the doorway of the Dakota, where he resided, riddled with four bullets.

Mark Chapman was found guilty of second-degree murder in the death of John Lennon and was sentenced to twenty years to life. While Chapman's defense team initially sought acquittal based on an insanity defense, Chapman chose to plead guilty. Chapman remains incarcerated in New York State. Eligible for parole in 2000, he was denied and has been denied every two years since by the state parole board.

The home the Chapmans rented in Roanoke was purchased in 1967 by First Presbyterian Church and later razed for a parking lot.

Chapter 13

TRAINING FOR THE
MORAL FEMALE CHARACTER

D r. William Anderson Harris, president of the Wesleyan Female Institute in Staunton, Virginia, announced in 1893 his plans to start a women's college in Roanoke. Harris had significant experience in leading colleges, having served previously as the president of Lagrange and Martha Washington Colleges. He chose as the location for his new college a ten-acre site in South Roanoke and called his enterprise Virginia College. This was viewed by civic leaders as a needed asset for the city given the number of wealthy families moving to Roanoke during that period.

The *Roanoke Times* reported, "The city should pause for a moment to think of the incalculable benefit to be derived from this school, as the patronage of this institute will bring forth educators for their children, ladies for their companions and helpmates in their struggles. Such a school will be the keystone to the city's prosperity." According to the newspaper, it was estimated at the time of the announcement that Virginia College would bring an annual economic impact to the city of $40,000. The ladies' college would provide a curriculum suitable for the "literary and moral culture" of young women.

The *Times*, in an eruption of prose, took note of the college's South Roanoke location:

> *The selection of its site is in itself a criterion of the wisdom of its projector,*
> *for from the miniature plateau of 10 acres, in the center of which the college*
> *will be located, the eyes can feed upon a ceaseless succession of magnificent*

pictures. The campus is Nature's art gallery, and that deified artist has wielded his brush with a grand and liberal hand—mellow-tinted hills are backed by giant mountains whose weird and solemn grandeur is relieved by yellow rifts of color, where the picturesque gorges breathe in the golden sun upon which the kaleidoscopic scenery feeds.

(The ten-acre site is where the present-day 3000 block of Rosalind Avenue is located, extending south from Twenty-ninth Street to Serpentine Road, west to Carolina Avenue and east to the eastern ridge of Mill Mountain.)

The ornate structure of the college was designed by the architectural firm of Wilson and Huggins of Charlotte, North Carolina, and would stand four stories with two 106-foot-long wings on each side. The first floor was designed to contain two offices, eight lecture halls, a laboratory, sixteen music rooms, a kitchen, pantries, a toilet, a store and housekeeper's rooms. The second floor would contain two parlors, a chapel, twenty bedrooms and two toilet rooms. The third floor contained twenty-five bedrooms and toilet rooms. The fourth floor would have art rooms, an infirmary and sun parlors. The building was completed in mid-July.

Virginia College opened for its first regular session on September 14, 1893. Its opening had been anticipated throughout the summer, with Harris advertising glowing testimonials about the school from prominent religious and political leaders around the state. In the first published listing of the faculty and their disciplines, one gains some understanding of the Virginia College experience. The opening session's faculty were as follows: Mrs. J.S. Boatwright, lady principal; Miss Lixxie J. Gibson, governess; Mrs. E.H. Stuart, matron; Professor William A. Smith, chemistry and physics; Professor C.B. Cannaday, English and mathematics; Elizabeth Jones, English and history; Lois V. Corprew, French, German and Latin; Madame Celine Early, French and German; Professor R.E. Hennings, director of music, piano, pipe organ and chorus class; Adelia Corprew, piano, guitar, harp, banjo and mandolin; Grace Martin, piano; Katherine A. Ivinson, voice culture; Sarah Hickey, supervisor piano practice; Mrs. J. deLong Rice, painting and drawing; and Cornelia May, elocution. The student body would be composed of both day and boarding students.

The young women at the college had a highly regimented schedule. According to student handbooks, the daily "Order of Duties" was as follows: 7:15 a.m., rising; 7:50 a.m., breakfast; 8:20 a.m., morning prayers; 8:30 a.m., recitations; 1:15 p.m., dinner; 2:00 p.m., recitations continue; 3:30–6:00 p.m., walks and recreation; 6:15 p.m., supper; 7:00 p.m., study hour;

9:30 p.m., prepare to retire; and 10:00 p.m., retire. This routine was strictly enforced by a "monitoress." In addition to these obligations, the college had numerous rules and codes of behavior. Only gentlemen visitors "from a distance" would be allowed to visit on the campus (local boys apparently could not) and then only with the authority of the girl's parents or guardian. All students were required to take daily walks with their teachers, and if girls chose to study in their rooms versus the Study Hall, they would be charged an additional thirty dollars in tuition for "fuel and lights." Protestant ministers could send their daughters to the college for free, and Bible study was required, with local Protestant clergy providing the lessons. All of this was in an effort to "train our pupils [in] all that is lovely and beautiful in female character," according to the college's handbook.

Dr. Harris died on September 4, 1895, after a brief illness and just days before the opening of the college's third academic year. Harris died at his residence at the college at the age of sixty-eight and was buried in Staunton alongside his wife, with services being conducted at the Methodist church there. The management of Virginia College was assumed by his two daughters, Mattie P. Harris and Gertrude Harris Boatwright. Both had been closely associated with the work of the college since its inception and opening. (Mrs. Boatwright was the grandmother of Robert Claytor, a president of the N&W Railway.) The sisters resided on the campus and monitored the behavior of students. A former student of the college, Mrs. Victoria Kegley, recalled in a 1981 interview the sisters as being "the epitomes of refinement, having big bosoms and beautiful attire, and riding in a chauffeur-driven car."

On the crisp fall Wednesday morning of November 14, 1900, Gertrude Boatwright began the activities at Virginia College with the usual sounding of the "rising bell" about seven o'clock. As students and faculty began preparing themselves for the day, Ms. Boatwright noticed a small amount of smoke filling a first-floor hallway near the west end of the building. Boatwright immediately alerted nearby students and then rushed up two flights of stairs to those on the upper floors. Within minutes, a thick black smoke began to fill all the passageways as students and faculty members fled the structure.

Unbeknownst to those fleeing the college, the fire had started in the boiler room, had engulfed that space and then began spreading up through the wooden walls of the college fanned by open windows in the basement. As Boatwright was alerting students above, a custodian who had been attending the boiler moments before was desperately trying to reach water cisterns to douse the flames. Repulsed by the thick, darkening smoke, the cisterns

Virginia College in South Roanoke, 1893. *Virginia Room, Roanoke Public Library.*

could not be reached. Within fifteen minutes, the grand, ornate structure of Virginia College had been safely evacuated but was now completely engulfed in flames.

At 7:18 a.m., city fire crews received the alarm via a phone call made by J.S. Perry from his home adjacent to the campus. When they arrived, there was nothing that could be done to save the structure. The scene was incredible. Female students stood on the college's lawn, many shivering in bathrobes, as firemen sought to protect other nearby structures. By eight o'clock, residents of South Roanoke had driven to the fire and were putting the students in their automobiles for warmth. Shortly thereafter, streetcars were dispatched to the campus by the Roanoke Street Railway Company to transport the students and faculty to Hotel Roanoke, where they were served breakfast.

As students and others left the grounds, the college collapsed into a smoldering mass of wood and brick. The lavishly furnished music rooms, dorm rooms with clothes and personal effects, the library and labs became

indistinguishable in a mass of charred remains. The next morning's headline in the *Roanoke Times* declared, "Fair Virginia College Burned to the Ground."

Grateful there had been no fatalities or serious injuries, the leadership of the college gathered the students and faculty later that same day in a meeting hall at the YMCA. (The students and faculty were being boarded in Roanokers' homes.) W.A. Glasgow, on behalf of the faculty, addressed the students and asked them to remain in homes and hotels for a few days until some decision could be reached about the immediate needs of the students and the continuance of the academic session. The students responded with applause and stood spontaneously to yell the college cheer. For all of the support and encouragement, the college still faced dire financial consequences as a result of the fire. The structure was only insured with Charles Lunsford & Son for about one-third of its value.

As news of the college's fire spread, Roanoke's business and civic leaders became concerned about losing the college permanently. The day after the fire, rumors began circulating about the college's future, as college officials were in a hastened search to find new quarters but remaining tight-lipped. Options being considered were several. Bedford leaders were proposing use of the Bedford Hotel and its grounds for a small price, and Salem officials were suggesting the Salem Hotel. Meanwhile, the students were being housed by local residents and appreciative of the hospitality. "Owing to the kindness and unrestrained hospitality of the people of Roanoke, all the students and teachers are being entertained…Not one of them escaped from the burning building with enough to clothe them. Many have heard from homes and are now provided with new outfits, sufficient for the time being. Those who have not yet heard from home have been supplied with all that they need. They will never forget the delicate kindness shown them," reported the *Roanoke Times*.

With the Virginia College fire, Roanokers were noting large fires consuming prominent structures in their city on a seemingly annual basis. The newspaper observed that over the previous years, fires had destroyed the Bridgewater Carriage Company, the Brunswick Hotel, the Norfolk & Western office building, the Hotel Roanoke and the Hotel Lee. Given the timber-frame construction of buildings at that time and limited firefighting service, uncontrolled fires were too common.

As the days passed, Virginia College leaders were being offered numerous inducements to relocate, permanently, out of Roanoke. Prior to the fire, the college had been at capacity enrollment and had just completed some additions to provide more dorm space for an even greater student body.

Offers were being reported as coming from Chattanooga, Bristol and Christiansburg. Supposedly, the Christiansburg bid was to supply the college accommodations at no cost courtesy of local merchants. Salem was actively soliciting subscriptions from its citizens to finance the college's location there. The *Bedford Democrat* was seeking to rally its readership. The day after the fire, it reported, "Attention, everybody...it is possible that the Virginia College of Roanoke whose buildings were destroyed by fire may be located here permanently. Every citizen of the town is requested to meet at the court house tonight to take some action in the matter." The *Democrat* noted that fliers were being widely distributed on the streets of Bedford advertising the meeting. Two days after the fire, Virginia College officials went to Bedford to tour the Hotel Bedford as a potential site, being met at the train station by Bedford's Mayor Campbell and all the members of the town council. Blue Ridge Springs was also on the list of visited sites within the region.

Staunton, where Dr. Harris had been previously leading a college before coming to Roanoke, had sent a delegation to call on Harris's daughters with inducements from the town. Buena Vista was offering its main hotel "already furnished as a school and ready to be occupied." Lynchburg, Danville and Waynesboro (known as Basic City at that time) were making personal calls as well. It was also widely known that the Harris daughters were traveling, making visits and having discussions with the various communities mentioned. This flurry of activity made Roanoke's social elite and business establishment nervous. Meanwhile, the college's students remained the objects of Roanokers' hospitality and were awaiting the outcome.

Urged by local politicians and business leaders, citizens of Roanoke gathered at the offices of Cocke & Glasgow in downtown to strategize about retaining Virginia College given the climate of competition. The *Roanoke Times* reported, "It seems to be the unanimous opinion of the citizens of Roanoke that every effort should be made towards the rebuilding of this property and the continuance of this institution in our midst." Business leaders had apparently pledged financial resources to that end, as the following day it was announced that commitments had been received from the Norfolk & Western Railway, the First National Bank and the National Exchange Bank in an effort to raise $20,000.

Within a few days after the fire, Virginia College officials announced that the college would be temporarily relocated to Buena Vista in order to resume the academic session. The college would move into a large hotel there that had been recently redeveloped as a school. The Norfolk & Western transported some ninety students plus faculty members by private

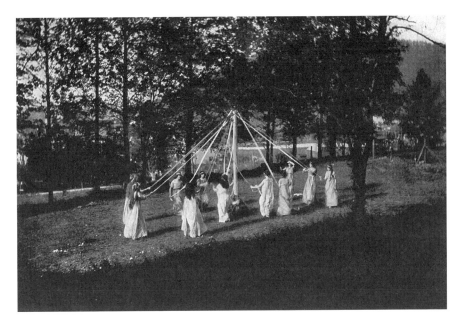

May Day fête on the campus of Virginia College, 1910. *Collection of the author.*

cars during that weekend to the city. The terms of the relocation were not reported other than the fact that "a satisfactory lease has been arranged." As for Buena Vista itself, the Roanoke newspaper noted, "it is a wide-awake city and is fully alive to the importance of its acquisition temporary though it may be."

With the relocation announced, speculation continued that Virginia College would not return to South Roanoke. The *Alexandria Gazette* informed its readers what numerous other papers around the state were reporting: "It is now settled that Virginia College, burned at Roanoke last week, shall be temporarily located at Buena Vista. It now seems probable, if the college is not rebuilt at Roanoke, that Bedford City will capture the prize."

The *Clinch Valley News* described the college's transition to Buena Vista:

> *Miss Harris, president of the college, would accept no building that was not heated by steam, fearing that students would suffer in health after becoming accustomed to the comforts of the college buildings. At length an excellent temporary location has been found in the handsome and sanitary building of the Buena Vista Hotel…Here the young women are pursuing their studies with the excellent faculty and administrative force of the college*

in direction, and they are hugely enjoying the novelty of college life in a comfortable resort hotel. The college rules and routine are followed and no serious interruption of studies has been caused.

With faculty and students comfortably settled at the Buena Vista Hotel, Roanoke's business leaders could focus on ensuring the college's quick return to Roanoke. Having already raised some funds, T.T. Fisburne, president of National Exchange Bank, convened a meeting of about a dozen prominent businessmen in his bank office located in the Terry Building downtown on Saturday, December 1. The purpose was to develop a plan to raise the remaining funds necessary to reconstruct the college at its South Roanoke location. In an editorial the day before the meeting, the *Roanoke Times* advocated for success in the endeavor. According to the newspaper, the college generated nearly $50,000 worth of business to hoteliers and others annually, brought families of "a most desirable class" to the city and advertised nationally, bringing recognition to Roanoke; the paper opined that "morally, it elevates the community." With this framework, the *Times* asserted that a failure to retain Virginia College "will be the darkest day in Roanoke's history...We might as well give up and settle down to a mediocre existence, adapt ourselves to the commonplace life of the unprogressive Virginia town and be done with it."

Fishburne and others had developed a plan to raise the remaining funds by offering stock at $100 per share with the arrangement being to rebuild the structures and then lease back the facility to the college. Thus, the stock was deemed not only a civic exercise but also a business investment. On Sunday, December 2, a letter from Fishburne appeared on the front page of that morning's edition of the *Roanoke Times*, headlined: "Keep Virginia College Here." In the rather lengthy piece, Fishburne outlined the basic financial needs of the institution and its importance to Roanoke. He wrote, in part, "I appeal to the good people of Roanoke, not only in the interest of the business of our city, but more especially in the interest of the higher and nobler work of mind and soul culture that is accomplished by an institution like this, to come to our aid and assist in the rebuilding of Virginia College in Roanoke." According to Fishburne, some $25,000 more needed to be raised. As a result of his meeting the day before, the amount had been reduced to $15,000. The Roanoke newspaper added, "This effort can be made. It must be made."

Three weeks later, Fishburne and Mattie Harris, president of the college, met with business leaders again and reported that the remaining amount to be raised was $4,000 and expressed confidence that the campaign would be successful. Harris expressed her desire that the college return to South

Roanoke, much to the enthusiasm of those in attendance. With completion of the stock campaign at hand, Fishburne appointed a committee to both conclude the capital campaign and develop plans for the rebuilding of the campus. Those on the committee were William Glasgow, Edward Stone, S.H. Heironimus, H.S. Trout and C.M. Armes.

Within a few weeks, financing was in place and the relocation of the college back to South Roanoke secured. The committee appointed by Fishburne retained the architectural services of S.S. Huggins of Roanoke, who developed plans for a new Virginia College similar to the original building. The construction contract was awarded to J.A. Parrish of Lynchburg, with the plumbing work to be done by A.J. Kenard of Roanoke.

By mid-August 1901, it was announced that the new Virginia College was ready for occupancy. The *Roanoke Times* described the building as follows: "The building resembles the old one but is much handsomer, better arranged and more comfortable. It is the same height, being four stories, but the pitch is greater making the ceilings higher and the ventilation better. The building is finished in colonial style with handsome pillars and broad attractive balconies." The article stated that the structure was finished inside with Carolina pine and that the only fireplace in the building that would ever be in use would be in the kitchen.

The first floor contained recitation rooms, the society hall (288 feet long), the office, a large dining room, the kitchen, lavatories, the matron's room and a private dining room. The second and third floors consisted of sleeping rooms, the assembly hall, the parlors, an infirmary and the reading room. The fourth story housed the art studio, the Christian Association room and the girls' clubroom. In all, the new college was a structure of 110 rooms with broad stairways leading down from every hall "so that the building could be emptied in very minutes in case of fire."

With the college campus now ready for students, advertisements for Virginia College ran in all the major newspapers across Virginia. The ads read: "One of the leading new schools for Young Ladies in the South. New buildings, pianos and equipment, campus 10 acres. Grand mountain scenery in the Valley of Virginia, famed for health. European and American teachers. Full Course. Conservatory advantages in Art, Music and Elocution. Students from Thirty States." Virginia College reopened in South Roanoke for the academic session on September 21 with a grand reception for new students, faculty, business leaders and the neighbors who had demonstrated hospitality during the temporary displacement of the students the previous fall.

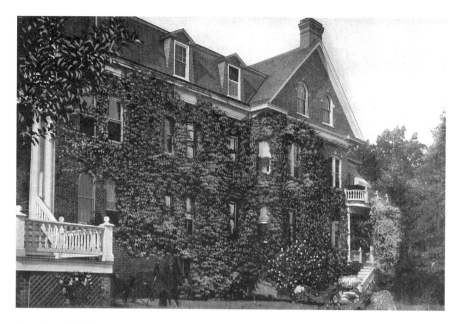

East view of Virginia College, 1910. *Collection of the author.*

In addition to the physical construction, Virginia College reasserted its mission of providing education and refinement for young ladies. Its handbook that year noted the college as "a place to inspire the youthful mind with beautiful and holy thoughts." Tuition, room and board for the 1901 academic year were $260.

For a quarter century, Virginia College opened its doors each academic session to young women from across the United States and abroad. In time, however, Mattie Harris's health began to fail and significantly impaired her ability to continue leading the institution.

A front-page headline in the *Roanoke Times* on June 5, 1927, confirmed what had been rumored for some months—that being the pending sale of Virginia College. A new corporation, headed by Dr. Charles Smith, president of Roanoke College, would acquire the campus on July 15. Other than Smith, all those associated with the corporation were kept anonymous, and the sale price was undisclosed. Aside from assuring the community that the new owners were local businessmen, Smith declared that the new corporation would be only supervisory and that his role was not in conflict with his position at Roanoke College. With this sale, the college facility would no longer be in the control of the Harris family, namely the daughters of the college's founder, William Harris.

Smith also shared the appointment of Mrs. Julia Abbott as the new administrative head of the institution and that it would continue to function as an all-female junior college. In his statement regarding all of these matters, Smith said, "Some months ago it became apparent to the owners of Virginia College that on account of increased responsibilities it would become necessary for them to relinquish the ownership and management of the college...Both from an economic and from an educational standpoint, its discontinuance would be unthinkable." The new ownership group was to be called the Virginia College Corporation.

Smith offered assurances that tuitions would remain stable, the mission would be retained and the campus improved. "I believe that this new undertaking will merit the interest and confidence of the citizens of Roanoke, and that it will serve many young local women as well as those who come from a distance. The college will be non-sectarian, but its operation will be along positively Christian lines," he concluded. Unfortunately, the assurances of Smith and the efforts of local business leaders to keep Virginia College operating would be short-lived.

The national economic collapse of 1929 claimed as a victim Virginia College. With the crash of the stock market, many students were called home by their parents, who were no longer able to afford their educations. Former students at the time later recalled that some of their classmates went home immediately, while others finished the fall semester but failed to return after the Christmas holidays, instead sending for their belongings. With a significantly diminished enrollment, Virginia College closed its doors in January 1930.

As for Mattie Harris, the last several months of her life confined her to an upstairs bedroom at her home on King George Avenue near Highland Park. Though ill, she continued to receive friends and those associated with the college, maintaining her keen interests in campus affairs and the world beyond Roanoke. Finally, on the morning of April 1, 1930, Miss Harris died, just a few short months after her beloved Virginia College was shuttered. Having never married, she was survived by two sisters, one of whom, Gertrude Boatwright, had served as Virginia College's vice-president.

Miss Harris's funeral was conducted the next day, at half past three o'clock in the afternoon, from the sanctuary of St. John's Episcopal Church with interment at Fairview Cemetery. The *Roanoke Times* noted Miss Harris's many achievements of being associated with the South Roanoke school. "Miss Harris was widely known in social and educational circles, and during the years of her administration of the local college, she numbered among

her students girls from every state of the Union…She was a woman of much charm and graciousness and her influence was felt wherever she went."

The campus of Virginia College remained closed for several months before it was purchased in 1930. Colonel Otey Crawford Hulvey announced his intent to purchase the property from the Virginia College Corporation and convert it to a boys' military academy. The colonel shared his vision for a school that would accommodate 250 young men and would be known as Harris Military Academy in honor of Virginia College's founder, Dr. William A. Harris.

Born in Staunton, Virginia, Hulvey had a long history with military academies in Virginia and throughout the South. He had been educated at Staunton Military Academy, Augusta Military Academy and the University of Virginia. He was a former commandant of the cadets at Kentucky Military Academy, president of Hay Long College in Tennessee, founder of the Tennessee Military Institute in Sweetwater and president of the Columbia Tennessee Military Academy from 1915 until 1919. He had also served in advisory capacities with military academies in Florida and Illinois.

Colonel Hulvey planned an aggressive campaign of marketing and enrollment for the 1930–31 academic session. "Harris Military Institute will be a non-sectarian school. Its curriculum will include all grades from the seventh through the high school and in the future it is the purpose of the management to add two years junior college work." Faculty members would be graduates from Virginia colleges and universities, and the War Department was to be asked to provide a commandant for the cadets. "Colonel Harvey will carry out the same policy here as in his former schools as to advertising, both local and national. The national advertising will include such magazines as *Saturday Evening Post, Literary Digest, Cosmopolitan, American Magazine* and *Redbook*. Papers throughout the state will also carry advertisements."

The acquisition of the Virginia College property by Hulvey was greeted with enthusiasm by local business leaders. The chamber of commerce helped to promote Hulvey's interest in locating to Roanoke and breathing new life into the college's campus. Gertrude Boatwright, the last surviving member of the Harris family, also expressed her public support.

For all of the fanfare, publicity and Hulvey's vast experience with successful military academies, Harris Military Institute remained open for only three academic sessions (1930–33), largely another victim of the Depression. In August 1933, its permanent closure was publicly announced. During those three years, many efforts had been made to create a successful boys' school on the South Roanoke campus. The previous year, the institute had discarded

its military component in a futile attempt to boost its enrollment. Colonel Hulvey had stepped down as president and relinquished the leadership to J.M. Lockman. The academy had failed to attract a sufficient number of local boys to its campus, and economic times created a scarcity of non-local boarding students. Fortunately, the school was closing debt free, but a projected enrollment of only forty students for the coming session that fall was too low to justify continuing.

In 1934, the campus was leased by the Federal Emergency Relief Administration for the purpose of a "re-educational school for unemployed women." Hundreds of women applied, with sixty admissions. The school lasted one year and closed.

This marked the end of Virginia College as an educational facility. For some four decades, the ten-acre college and its campus had been a grand neighbor in South Roanoke, occupying its hillside perch. The college, over its time, had welcomed young ladies from every state in the Union (thirty-four at that time) and eight foreign countries; had employed numerous faculty, many of whom were from Europe; and had maintained a campus open to South Roanokers for their enjoyment, civic picnics and recreation. The May Day dances, music recitals, fern-decked verandas, cultured summer guests and young ladies who regularly strolled along Carolina, Virginia and Rosalind Avenues would fade into memory. Promoted as one of the greatest female colleges in the South, the beautiful structure slowly declined into disrepair.

In September 1936, Frank Graves purchased the property with the intent of converting the college into apartments. His plans were scuttled by the Roanoke City Board of Zoning Appeals, which denied his request for a conversion permit. In July 1937, some two thousand volumes, representing the remainder of Virginia College's library, were purchased by the Town of Salem for its public library located in Younger Park.

Finally, by January 1939, the college had been razed, its campus subdivided into residential lots (known as College Park on plot maps), and it was no more.

—◆◆◆—

Roanoke's last formal connection with Virginia College came to an end in 1953 with the passing of Mrs. Gertrude Boatwright. As for the other schools associated with Dr. William Harris, founder of Virginia College, they followed much the same fate. Dr. Harris had served as president of the

Martha Washington College in Abingdon, Virginia. That school closed in 1931 with the old campus being the present-day Martha Washington Inn. The Wesleyan Female Institute in Staunton went bankrupt in 1899 when the Methodists shifted their funds to Randolph-Macon College. The closings of these female colleges is in no way a reflection of the leadership of Dr. Harris but a reminder of the precarious economic conditions faced by many of these schools.

Chapter 14

MANHUNT

Judge Massie shot dead on the bench, commonwealth shot dead at the bar,
the sheriff shot dead in courthouse, several others wounded, help wanted.

The words of the Western Union telegram delivered to Virginia governor William Mann on the morning of March 14, 1912, succinctly summarized the worst courthouse tragedy in United States history up to that time. The shooting at the Hillsville courthouse on that Thursday morning was the result of a long-simmering feud between the Allen clan, headed by Allen family patriarch Floyd Allen, and local law enforcement officials. The Allens had a history of settling matters outside the bounds of the law in Carroll County, having reputedly killed their own kin in various disputes, not to mention threats and other measures taken against neighbors who dared to cross them. Floyd Allen was appearing in court on a charge of breaking his two nephews out of custody from two deputies following their arrest on a charge of disturbing the peace due to a fistfight they had started during a church worship service. While Allen's trial had begun two days earlier, the Thursday morning session was held to hear the jury's verdict, the judge, Thornton Massie, having received word late Wednesday afternoon that the jury's deliberations had concluded. The court session opened at 8:00 a.m. Others present in the courtroom included Allen's two nephews, Sidney and Wesley Edwards, and his brothers Sidna and Claude Allen. The courtroom was packed with locals who viewed the trial of Floyd Allen as both entertainment and a

valiant effort by some to deliver justice to a clan that had bullied residents of Carroll County for far too long.

The jury foreman read the verdict of guilty and announced Floyd Allen's sentence to be one year in jail. Over the objections of Allen's attorney, Judge Massie upheld the verdict and sentence, refused bail and ordered Sheriff Webb to take custody of Allen, prompting the defendant to rise from his chair and shout in Massie's direction, "I will be damned if I am going!"

Who fired the first shot remains a matter of dispute, but within minutes bullets riddled the courtroom, and bodies lay either dead or injured. Judge Massie fell beside his chair, the victim of three bullets; Sheriff Webb collapsed dead with five; and the commonwealth's attorney was struck six times and, according to witnesses, died before he hit the floor. Court clerk Dexter Goad was struck in the cheek and managed to return fire along with others as the Allen clan fled the courtroom. In a final gunshot from Floyd Allen, Miss Betty Ayers, slated to be a witness in another matter later that morning, was struck and managed to stay death until the next day.

In the street outside the courthouse, spectators panicked as Goad and others continued to fire at the fleeing Allens, wounding Floyd and Sidna. Amid the hail of bullets inside the courtroom, five jurors had been struck, one fatally, and Goad had been grazed eleven times. Based on bullets lodged in walls and bodies, some fifty-seven shots had been fired. It was a bloodbath.

In 1912, Hillsville lacked adequate telephone and telegraph service, so a rider rode furiously to Galax, thirteen miles away, to wire the message to Governor Mann describing the tragedy and to plead for assistance. One can only imagine what went through the governor's mind on that morning as he sat at his desk conducting routine business when an assistant handed him the message, but the governor responded quickly. Several minutes later, he enlisted the aid of the Baldwin brothers, notably William Baldwin in Roanoke. The governor's telegraphed message read: "Judge, commonwealth's attorney, and sheriff at Carroll County shot dead in courthouse at Hillsville. Take such men as you think necessary and proceed at once to Hillsville and arrest murderers and all connected with the crime. Spare no expense and call on me for any help needed."

The governor's telegram granting such broad range of authority to the Baldwin brothers and their men was not only decisive but also a demonstration of complete confidence in their ability to manage the situation and represent the powers of the governor's office. William Baldwin and his brother, Dennison "Den" Oscar, were partners in the Baldwin-Felts Detective Agency, with a main office located at 110 South Jefferson Street

in downtown Roanoke. William Baldwin had been a private detective for nearly a quarter century, working for mayors, governors, mine owners and the Norfolk & Western Railway. The fact that Baldwin's younger sister was married to the president of the N&W certainly helped his business. By the time Governor Mann enlisted Baldwin's aid, Baldwin and his agency had involved themselves with several manhunts, the West Virginia mine strikes and even the Hatfield-McCoy feud in West Virginia. Baldwin had a reputation of being honest, diligent and tireless in his work for whoever anteed up a contract.

Baldwin and the governor's office exchanged telegrams throughout the day on March 14, and the added concern was that Hillsville remained largely unprotected with the death of the sheriff. Baldwin's men began moving toward Hillsville from all directions, including the branch office in Bluefield, West Virginia. By nightfall, enough Baldwin-Felts men were in Hillsville that order was restored; some of the Allen gang, including Floyd, apprehended; and a manhunt undertaken for those remaining on the loose. All of this was being coordinated by William Baldwin from his office in Roanoke, and by the next day, that effort included seventy-five men scouring the surrounding counties for the murderers. Rumors were rampant, so Baldwin requested that the governor construct a telegraph wire to Hillsville so he could hear directly and quickly from his detective stationed there. Baldwin had the Stone Printing and Manufacturing Company in Roanoke produce wanted posters complete with reward amounts; for Sidna Allen, $1,000; Claude Allen, $800; Freil Allen, $500; Wesley Edwards, $500; and Sidney Edwards, $300. The posters noted that all the men were "mountaineers" and "heavily armed and desperate." Perhaps most eye-catching was Baldwin's stipulation that the rewards would be granted for any of these men "Dead or Alive." A second poster was printed on March 23 with photographs. Within a few days, two of the fugitives had been caught—Sidney Edwards and Claude Allen. A week later, Friel Allen surrendered, leaving two on the run. While Sidna Allen and Wesley Edwards had allegedly been spotted by witnesses in the Carroll County area, they had eluded capture, and Baldwin was unconvinced they were still in the state. Thus, by early April, Baldwin had sent wanted posters to sheriffs and police chiefs in seven states, as well as to train masters of all the major southern railways. Baldwin was now coordinating the largest, most extensive manhunt in Virginia's history.

Baldwin's Roanoke office was a hub of activity, with reporters from newspapers across the country wanting details and updates on his work. Keeping all information closely guarded so as to not tip off the fugitives via

a newspaper report, Baldwin would soon realize the press could be his ally. A major break in the case, now in its third week, came as a result of Baldwin himself committing an illegal act, intercepting the mail of Sidna Allen's wife. In one letter provided to Baldwin, an Allen cousin—who had killed two persons himself in his home county in Tennessee—indicated he was harboring the two fugitives in or around Roane County, Tennessee. At this same time, Baldwin had to do something with those who had been captured, and believing that they could not be held safely or securely in Hillsville, Baldwin had the men transferred to Roanoke, where his own men could help guard them.

As the search for Sidna Allen and Wesley Edwards continued, the other accused men were taken in the pre-dawn hours of April 22 to stand trial before Judge Walter Staples in Hillsville at the same courthouse where the tragedy had occurred. Baldwin, accompanied by six of his men, left Roanoke at 4:00 a.m. and headed to Galax, where they were joined by four other detectives. "When we arrived in Hillsville…we found quite a number of Allen's friends on hand and others coming in…we increased our guard force [to] seventeen men on duty," recalled Baldwin. Floyd Allen's trial was moved to Wytheville and commenced on April 12.

As the trials of the various defendants moved forward in Hillsville and Wythe County, Sidna Allen and Wesley Edwards had managed to make their way to Des Moines, Iowa. Using the aliases Tom Sayers and Joe Jackson and working as carpenters, they were rooming in Mrs. John Cameron's boardinghouse. As spring merged into summer, their trail had grown cold as they quietly settled into Des Moines, even joining the carpenter's trade union there. Baldwin was frustrated and was spreading his detectives thin in both guarding courthouses for the trials and simultaneously maintaining an ongoing manhunt for the two elusive fugitives.

A break finally came on August 19, when the father of Wesley Edwards's girlfriend, displeased by his daughter's romantic affections, informed Baldwin that she had made contact with Edwards. Eventually, sufficient evidence was gathered to track Edwards and Allen to Des Moines, and Baldwin left Roanoke in mid-September for Iowa. With the assistance of that city's police chief and two of his own men, Baldwin successfully surprised Allen and Edwards and arrested them without incident.

Baldwin returned to Roanoke with his two fugitives and was greeted by a cheering crowd, many wanting a glimpse of the two men they had read so much about. Among the faces in the crowd was local photographer George Davis, who took a picture of the crowd gathered in the street outside the office of the Baldwin-Felts Detective Agency.

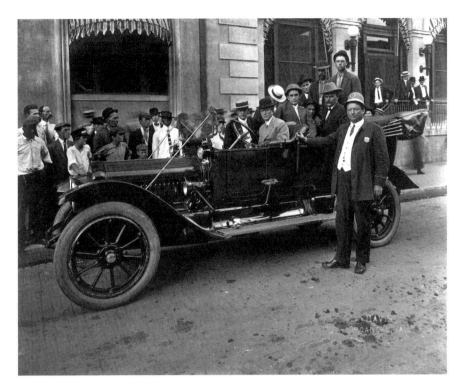

W.G. Baldwin organized the capture of Sidna Allen and Wesley Edwards and brought them to the Roanoke jail before they were transported to Carroll County. Baldwin is seated in the rear of the car with moustache and hat, and Allen and Edwards are standing behind him. This 1912 photo was taken at the northeast corner of Church and First Streets. *Virginia Room, Roanoke Public Library.*

After six months, a manhunt that involved over eighty Baldwin-Felts detectives searching across five states, guarding the trials of six men and numerous state and local law enforcement officials, William Baldwin had successfully managed the capture of all members of the Allen gang involved in the Hillsville shootout. The tragedy, the trials and the efforts of Baldwin and his men to bring fugitives to justice had been covered on the front pages of almost every major newspaper in the United States, providing Baldwin and his Roanoke-based agency a stature exceeded only by the Pinkertons. Baldwin had conducted his investigation and manhunt in an era that predated the role that would now be filled by the Federal Bureau of Investigation or a more sophisticated state police agency. His means, while often legally dubious, proved effective.

Sidna Allen stood trial on November 27 and was convicted and sentenced to thirty years for the murders of Judge Massie and Sheriff Webb. Wesley Edwards confessed to his role in the Hillsville tragedy and was sentenced to twenty-seven years. As for Baldwin, he quickly turned his attention to subduing a bloody coal miners' strike in West Virginia.

———◆•◆•◆———

Floyd and Claude Allen were electrocuted by the commonwealth on March 28, 1913. Both maintained their innocence to the end. Friel Allen and Sidney Edwards were pardoned by Governor Lee Trinkle on October 6, 1922, following an outpouring of public sympathy for the men and evidence that other Allen family members had cooperated with the Baldwin-Felts detectives in exchange for leniency for the two men if convicted. In the decade that followed Sidna Allen's and Wesley Edwards's convictions, there was growing sentiment suggesting that the Allens may not have been the first to fire shots in the Hillsville courthouse, and thus began a petition drive to pardon Allen and Edwards. On April 29, 1926, Governor Harry F. Byrd acquiesced and pardoned the two men, who returned to Carroll County. As for William G. Baldwin, he continued to work as chief special agent for the N&W Railway, retiring at age seventy on May 25, 1930. Baldwin managed his varied Roanoke business interests, including his ownership of the Martha Washington Candy Company, which grew to fifty-seven stores along the East Coast, and investments in the Evergreen Burial Company and Mountain View Cemetery. Baldwin also served as a director for the Colonial National Bank and the Liberty Trust Company and was a charter member of the Roanoke Lodge of Elks. Baldwin died after a long illness on March 31, 1936. The Baldwin-Felts Detective Agency continued for one more year, conducting its last investigation, an embezzlement case at Nelson Hardware, in August 1937.

Chapter 15

A STAR IS BORN

The Christmas Street Decorations Committee of the Roanoke Merchants Association was in a quandary. For years, the committee had overseen the Christmas lights that illuminated Roanoke's downtown during the holiday shopping season. But in the spring of 1949, the committee wanted to think more grandiose, to develop a Christmas attraction that would significantly surpass what many had come to expect.

The committee solicited ideas, and round-table discussions followed that prompted several thoughtful suggestions. One idea was to erect a large cross on the roof of one of the buildings downtown. The Christian symbol would certainly be in keeping with the season. Another was to purchase strands of large multicolored lights and drape them in the tops of trees on the western slope of Mill Mountain such that the figure of a large Christmas tree would be formed. Thoughts were running in the right direction—something large and visible—but the gigantic cross or the lights on trees seemed to fall short, not to mention presented certain challenges.

Edward "Ted" Moomaw would later recall that it was either Kirk Lunsford Jr. or Fred Mangus who initially suggested to the committee the idea of a star on Mill Mountain. They perhaps had been approached by Roy Kinsey, a local sign designer, who had spied an illuminated star on a recent trip and broached the subject with the two men. Whatever the case, as success always has many fathers, the Christmas Street Decorations Committee decided to pursue it.

A large neon star on Mill Mountain had numerous obstacles, so the committee set to work. It met with J.B. Fishburn, who had donated the

mountain to the City of Roanoke, to receive his blessing. While Fishburn could not claim veto power per se, the committee knew that without his acquiescence, the city's permission would be difficult to obtain. The star would have to be sized, engineered and financed and access obtained to the site. With no experience in such a matter and armed with loose estimates of the work and money involved, the committee members got approval to proceed from the Merchants Association with an anticipated budget for the project of $25,000. The Roanoke Chamber of Commerce responded cautiously, accepting no financial responsibility for the star but agreeing to help raise funds.

The committee's goal was to have the star in place and turned on by Thanksgiving Eve, November 23. It was an ambitious plan. The Roy C. Kinsey Sign Company was immediately contracted to build the star, with Robert L. Little of the Roanoke Iron & Bridge Works to design it.

Dewey Wynn, merchants association president, and Edward Ould, chamber of commerce president, sent a joint letter to area businesses soliciting their financial support and even suggesting the levels of their contributions. While some responded with compliments and checks, others were less than enthusiastic. One businessman sent in a ten-dollar bill with a note that he was donating for them not to build the star! Others complained that the association and chamber were spending "their" money on a project to which they had not agreed.

City fathers eyed the project with a dose of skepticism. The proposed location for the star was where an old observation tower had once stood, and there had been some discussion about erecting another one on the same spot. City manager Arthur Owens openly wondered if the star could be moved or was to be a permanent fixture. City council members were worried that by granting permission for the star to be built, they would lose control of Roanoke's most valued overlook and made it plain they would grant only a temporary easement. Some citizens complained it would ruin the mountain and be nothing more than a tacky eyesore.

Encouraged by many and criticized by a few, the committee's plan moved forward under the watchful eye of Kinsey, who threw himself wholeheartedly into the project. The fundraising effort met with success, though the project would run over budget by $3,000, the balance of which would be paid by the merchants association. The star required 2,000 feet of neon tubing, 125 cubic feet of concrete weighing 500,000 pounds, 5,000 pounds of reinforcing rods and 60,000 pounds of steel framing, all of which had to be transported up the mountain.

As Thanksgiving Eve approached, crews worked tirelessly to get the star ready. Stressed by a tight schedule under the best of circumstances, city officials and the merchants association could only watch helplessly as strong winds, snow and even sleet pelted the Roanoke Valley for several days in mid-November. Claude Harrison, heading the publicity effort for the association, had invested significant personal energy into amassing a media blitz cued for Thanksgiving Eve. National magazines and wire services had been coaxed into covering the star's illumination, and local television and radio stations had promised to carry the lighting ceremony live. Mayor A.R. Minton had extended invitations to some 225 mayors throughout Virginia, West Virginia, Tennessee and North Carolina to attend the event, and many had indicated they were coming. And yet the weather continued to be uncooperative. The *Roanoke Times* reported on November 20, "Adverse weather conditions are the bugaboo that may halt construction on the 88-foot star. If snow flurries and wind become no more severe, the job will probably be completed on time. But if the elements become any more troublesome, there could be a postponement."

By the morning of Thanksgiving Eve, doubts remained about the lighting ceremony. "Delay Might Be Caused by Inclement Weather," read a headline that morning with word that a 10:00 a.m. meeting was being held to decide whether to proceed with the ceremony or develop an alternative plan. By late morning, however, the skies had cleared, though the wind and cold remained, and the decision was made for the lighting ceremony to go forward.

At 8:00 p.m., some 250 dignitaries and invited guests assembled at the foot of the star amid a whipping wind on Mill Mountain to start the lighting ceremony. For those listening to WSLS Radio, George Chernault announced, "Atop Mill Mountain, in Roanoke, Virginia, a star is born!" Listeners then heard the fifty voices of the Greene Memorial Methodist Church choir under the direction of Mrs. Eula Ligon sing "America!" followed by master of ceremonies James Moore's introduction of Judge Clifton A. Woodrum as the main speaker. Woodrum likened the star to the one that shone over Bethlehem. Quoting Matthew 2:10 from the New Testament, Woodrum solemnly intoned, "When they saw the star they rejoiced with exceeding great joy." The former congressman continued, "The Star of Bethlehem lights the only path to peace this earth will ever know. Let us fervently pray that the light of the star shall be an inspiration to us as a people, a community and as individuals to rededicate our lives to the spirit of useful service and everlasting peace."

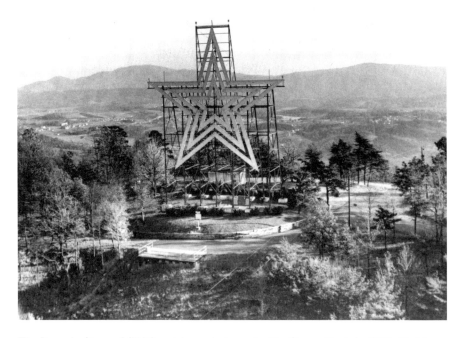

The Roanoke Star on Mill Mountain as photographed by George Davis in 1950. *Virginia Room, Roanoke Public Library.*

Moore returned to the microphone and introduced Mayor Minton. "It is indeed a rare privilege to throw the switch making Roanoke 'The Star City of the South.'" With that, the mayor threw a ceremonial switch at 8:22; the star blinked on, then off, then on and was lit.

The Greene Memorial choir sang "The Star-Spangled Banner" and "The Battle Hymn of the Republic." The Reverend Frank Efird, president of the Ministers' Conference and pastor of Christ Lutheran Church, closed the program in prayer: "Let the beauty of this star remind us of the beauty of holiness and righteousness that should prevail among people under God. And may the business and industry beneath its rays be good not only financially but morally."

The twenty-minute ceremony, a mixture of the sacred and civic, was being heard on three local radio stations and from loudspeakers posted in three designated city parks—Elmwood, Wasena and Jackson—and at Woodrum Field. WROV Radio stationed four announcers to broadcast on the national *Mutual Newsreel* program from strategic vantage points across the

city. Gordon Philipps was on Mill Mountain, Jim Shell and Don Bowman were on the top of the Mountain Trust Bank Building and Lee Garrett was at Woodrum Field.

Thousands of Roanokers tuned in from their car radios such that traffic jams occurred on South Jefferson Street and Franklin Road. On Brandon Avenue, cars were bumper-to-bumper for over half a mile.

Many Roanokers watched with anticipation from their yards, front porches, roofs and street corners. Downtown, some seventy-five Boy Scouts, upon seeing the star, lit one hundred three-foot red stars hanging from lampposts and utility poles.

Perhaps the most advantageous view of the Mill Mountain Star was had, not by those on the ground, but by two men in the air. Flying at six thousand feet on Eastern Airline Flight 754, Captains Arthur Robertson and Don Purcell first saw the star from Martinsville. "At first it looked like a point of light. As we approached it, we began to distinguish the shape of the star. It's the most beautiful thing I've ever seen," said Robertson.

The event was noted in newspapers across the country, including those in New York, Washington, Detroit, Memphis and Savannah. A newspaper in Australia even featured "the largest man-made star in the universe." Lowell Thomas and Ted Mack reported the lighting on national radio broadcasts, and images of the star graced *Life* magazine.

The next day, some twenty-six thousand spectators, including Virginia's governor-elect John Battle, gathered beneath the star in Victory Stadium and watched Virginia Military Institute and Virginia Polytechnic Institute play their annual football game, a contest that ended in a 28–28 tie.

The first line of the *Roanoke Times*'s Thanksgiving Day story on the illumination of the Mill Mountain Star put it correctly: "The City of Roanoke flashed its symbol of progress to the world last night."

<hr />

The Roanoke Star is today the signature symbol for the city of Roanoke, known as the "Star City of the South." It remains the world's largest freestanding man-made star, and the star is recognized on the National Register of Historic Places. The Roanoke Merchants Association transferred "ownership" of the star to the City of Roanoke in 1982.

Selected Bibliography

Primary Sources

Alexandria Gazette
American Wool and Cotton Reporter
Atlanta Constitution
Bedford Democrat
Clinch Valley News
Florida Sentinel
Holland, Alphonzo. Personal interview, September 2012.
Louisiana Capitolan
Louisiana Democrat
New Orleans States
New York Sun
New York Times
Richmond Daily Dispatch
Roanoke City Directory, various years.
Roanoke Evening World News
Roanoke Times
Roanoke Times & World News
TIME magazine
Washington Post

SECONDARY SOURCES

Barnes, Raymond. *A History of the City of Roanoke*. Radford, VA: Commonwealth Press, 1968.

Berrier, Ralph. "Color Barrier: The Jackie Robinson Legacy." *Roanoke Times*, May 4, 1977.

Dotson, Rand. *Roanoke, Virginia, 1882–1912: Magic City of the New South*. Knoxville: University of Tennessee Press, 2007.

Harris, Nelson. *Greater Raleigh Court: A History of Wasena, Virginia Heights, Norwich & Raleigh Court*. Charleston, SC: The History Press, 2007.

Herbert, Hiram J. *Shenandoah Life: The First Fifty Years*. Roanoke, VA: Shenandoah Life Insurance Company, 1966.

Howard, Durrell J. *Sunday Coming: Black Baseball in Virginia*. Jefferson, NC: McFarland & Company, 2002.

Jones, Jack. *Let Me Take You Down: Inside the Mind of Mark David Chapman, the Man Who Killed John Lennon*. New York: Villard Books, 1992.

Kegley, George. "Henry Ford and Friends on Tour." *Journal of the Roanoke Valley Historical Society* 3, no. 2 (1967).

Moomaw, Edward C. "How the Star Was Turned On." *Journal of the Roanoke Valley Historical Society* 11, no. 2 (1982).

Velke, John A., III. *Baldwin-Felts Detectives, Inc*. N.p.: privately published, 1997.

About the Author

Nelson Harris is a native of Roanoke, Virginia, having graduated from Patrick Henry High School, class of 1983. He holds degrees from Radford University (BA, cum laude) and Southeastern Baptist Theological Seminary (MDiv). He has done postgraduate study in religion at Princeton Theological Seminary and in philosophy and ethics through Harvard University.

Harris served as a member of the Roanoke City Council, twice as vice-mayor, from 1996 to 2004, and then was elected to one term as the city's mayor from 2004 to 2008. He has been active in regional civic and historical organizations, including as a member and chairman of the Roanoke School Board and as a member of the boards of Radford University, the Historical Society and Museum of Western Virginia, the Grandin Theatre Foundation, the Hotel Roanoke Conference Center Commission and Virginia Baptist Homes, Inc.

Harris is the minister of Virginia Heights Baptist Church in Roanoke and an adjunct faculty member in religion and philosophy at Virginia Western Community College. He has also taught for Bluefield College.

He has been published in numerous magazines and journals, including regional publications such as *The Roanoker*, the *Journal of the Historical Society of Western Virginia*, *Virginia Southwest* and *Historic Salem*. His on-air essays have been featured on WVTF, local public radio. Mr. Harris has had several books published on local history, including *The Seventeenth Virginia Cavalry*; *Roanoke in Vintage Postcards*; *Images of Rail: The Norfolk & Western Railway*; *Virginia Tech*; *Stations and Depots of the Norfolk & Western Railway*; *Salem and Roanoke County*

in Vintage Postcards; *Greater Raleigh Court: A History of Wasena, Virginia Heights, Norwich and Raleigh Court*; *Downtown Roanoke*; and *Roanoke Valley: Then & Now*.

Harris and his wife, Cathy, have three sons, John, Andrew and David.